W9-AEE-215

Dreaming from the Journal Page

TRANSFORMING THE sketchbook TO art

by MELANIE TESTA

NORTH LIGHT BOOKS
Cincinnati, Ohio

contents

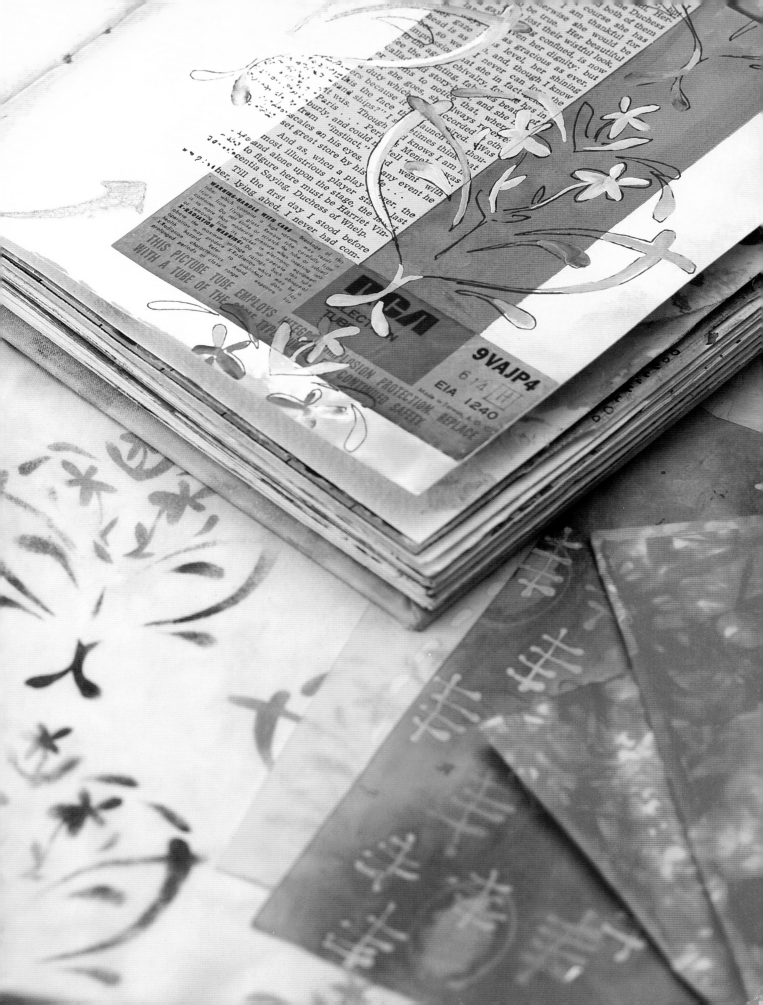

introduction

Opening a journal to draw, paint, doodle and make marks expands your creative potential and is nothing short of revolutionary. Visual journaling or keeping an artist's journal is a dialog, an opening to the self artistically, a place of visual exploration that will lead you on creative and intellectual journeys never before dreamed of. It serves as an extension of your imagination, becoming a receptacle of creative ideas and a source of artistic renewal. It supports you as an artist, pays into your creative talent and is an investment in you artistic voice and singular vision, while training your mind, eyes and fingers to render original ideas. There is no one in the world quite like you, and you want your art to have a voice that is as diverse, engaged and expansive as you know yourself to be.

In this book, I present techniques for you to use in your journal practice. All of the techniques can be used on paper, and most can be used on cloth as well. There are techniques that have direct correlations. Frisket paper (a low-tack, adhesive stencil plastic), for example, is a mask that when used on paper yields results similar to those achieved when using freezer paper, a plastic-coated paper with a shiny side that irons easily to cloth. As you progress through the pages of this book, you are encouraged to layer, build and use multiple techniques on a single page, giving your ideas depth, dimension and maturity. Wherever possible, we will make connections between the similarities and differences between paper and cloth—these are called Jumping-Off Points.

There are project ideas scattered throughout the book as well. I present these techniques and ideas in the hopes of pushing the horizon of possibility farther than you might imagine. Always remember that these are techniques, not goals in and of themselves.

Let's begin the journey of learning, making mistakes and experiencing moments of ecstatic accomplishment. To each mistake and accomplishment say, "Wow!" out loud and with childlike abandon! Do not judge your efforts; merely experience them and strive for better results. We embark on a personal journey to find your artistic voice and vision. This is the journey of a lifetime and can only be reached one step at a time. Make it permissively and wonderfully yours.

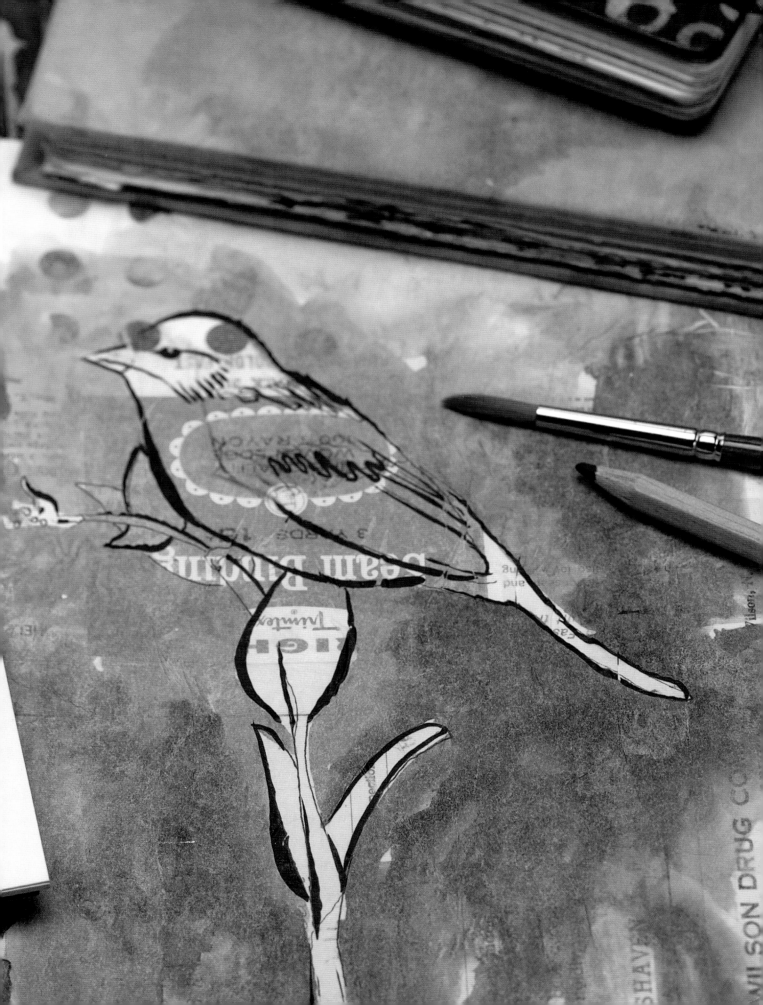

1

The What

There are as many ways to keep a journal as there are people who feel the need to do so. Because we are exploring what it means to keep an artist's journal, you will need more than just the prerequisite of the journal itself. I rarely leave home without at least the simplest of supplies: a book and a pencil. But more often then not, I also carry a box of watercolors or gouache paints, a few choice pens, two sizes of waterbrush—small and medium—and an eraser.

An artist's journal helps you bring ideas to the forefront of your visual plane, so having a few additional supplies in your holster is a good idea. In addition to techniques for use on paper (and wood and similar substrates), we will explore low-immersion dyeing techniques, painting on fabric and soy wax used as a resist on both paper and cloth. This new resist medium has so many possibilities, it is just amazing.

Once you begin storing and creating a stash of surface-designed papers, cloth, stamps, stencils and drawings inspired by your journals, you will see just how expansive your creative process will become. Here are some tips concerning supplies and such to get you started.

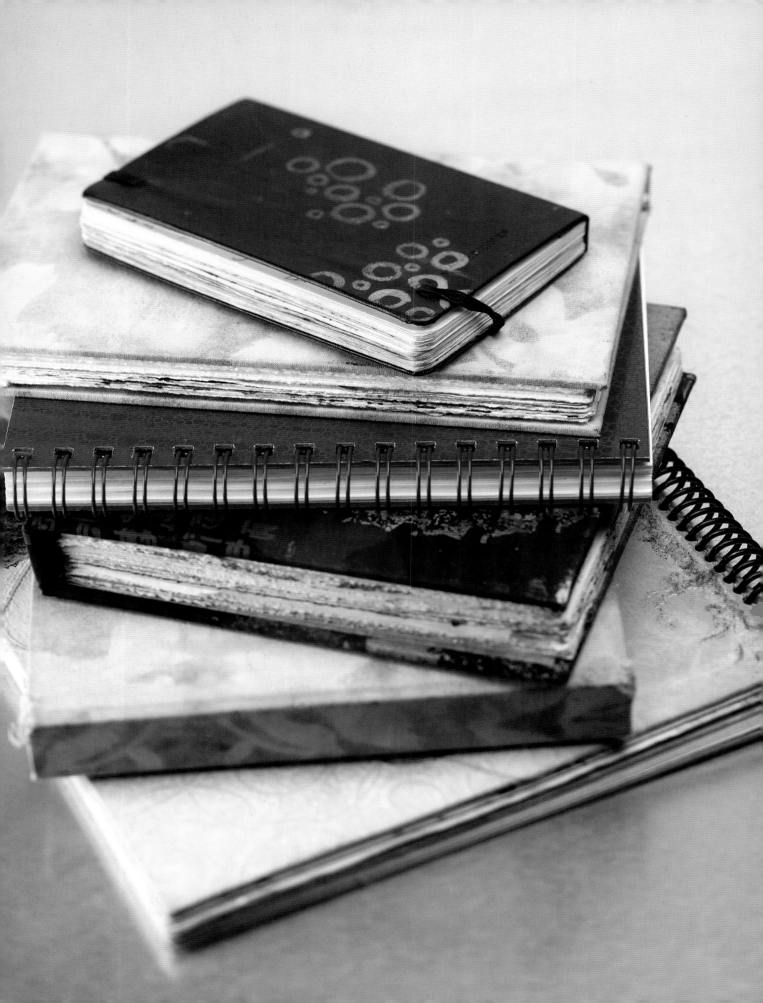

Journals

CHOOSING A JOURNAL

A good place to begin journal shopping is to question your available art supplies and your intentions. Do you want to experience the wonders of applying watercolor paints to wonderfully sized watercolor paper? Do you want to use every paint in your arsenal and not care what paper or paint you choose to use? Would you rather start out tentatively, purchasing a less expensive array of tools in order to try your hand at all the techniques listed in this book? This is your journey and I encourage you to embrace what works best for you and to clear the way for your best efforts to come to fruition.

Strathmore Visual Journals are good entry level journals that will support wet, dry and creamy media. The paper in this spiralbound journal comes in two weights, 90 lb. or 140 lb. The covers are hard and could withstand a decent painting, some collage and the addition of fun, though I bet a light sanding would encourage paint and glue applications to adhere better.

Moleskin Sketchbooks and Watercolor Books are good for gouache and watercolor paints. That is to say, gouache is the only paint that can be used in the Moleskine Sketchbook, while both gouache and watercolor can be used in the Watercolor Book. Moleskine Sketchbooks and Watercolor Books come in two sizes, 3½ x 5½" (8.90cm x 14cm) or 5 x 8½" (12.75cm x 21cm); the Watercolor Book opens in landscape format, while the Sketchbook opens in portrait orientation.

I am currently entrenched in making my own journals, and you will see some of these within the pages of this book. I will leave discussion of bookmaking techniques and approaches to those whose skills are far better than my own, but I will discuss some of the paper I have found to be delicious and why. Of course you can purchase some of these papers, bring them to a copy shop that has the ability to cut them to size and apply a spiralbinding, and make an experimental book of papers for you to assess your own likes and dislikes.

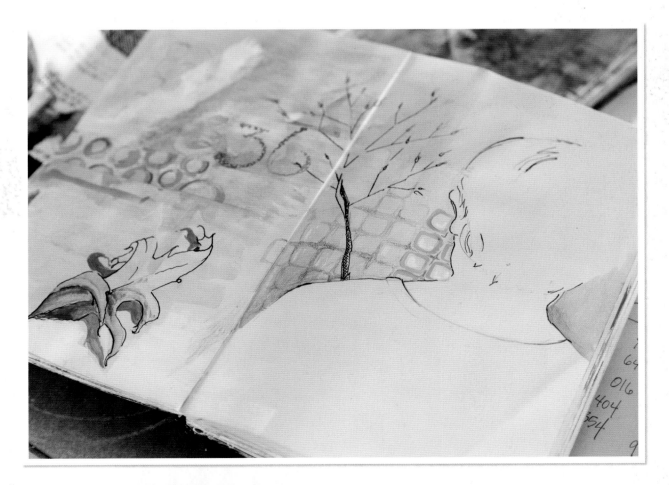

Paint

Begin collecting a limited palette in each of the paints that suits your needs best. Include watercolor, gouache and acrylic paints. A limited palette will allow you the time to get to know the individual properties of each color. My preferred M. Graham paints use the same pigments in all of their paint offerings, so when you mix watercolors, you are also storing knowledge of how the gouache and acrylic paints will mix.

Many paint manufacturers sell grades of paint—professional or student grades that list the pigments used in their formulations. Paint sold for the craft market, however, is not graded. Professional grade paints use the best pigments, ingredients and formulas, and as such, they're more expensive. Student-grade paints are more affordably priced due to the inclusion of lesser grade pigments and carriers. Craft-type paints are sold to be used straight from the bottle and are not formulated with specific or labeled pigments. I discourage you from using craft paints to learn about color mixing. (For more on color mixing, see *Chapter 2, Get to Know It.*)

ACRYLIC PAINT

Because we are using acrylic paint in a broad range of applications, you will want to purchase paints, both transparent and opaque, formulated for use on cloth. In addition you may want to keep a supply of acrylic paints intended for use in fine art painting, but you will need a medium to help the paint adhere properly to cloth. For this purpose, Golden manufactures a medium called Silkscreen Fabric Gel.

And acrylic craft paints can be pretty enticing, with halo-gold, shimmery glitter, puffy, shiny and other effects that will excite your inner magpie. Use them to your heart's content—just be aware of their limitations.

WATERCOLOR AND GOUACHE

Both watercolor and gouache are considered watercolor-type paints. Watercolors are wonderfully transparent, mercurial paints that will show off the qualities of the paper beautifully. Transparent watercolors are versatile, allowing you to layer colors, one atop the other, work wet on wet, and create gradations and washes of color, all while allowing for a great feeling of freedom and play.

My Chosen Color Palette

- Burnt Sienna
- Yellow Ochre
- Gamboge Yellow
- Azo Yellow
- Napthol Red
- Quinacridone Violet
- Dioxazine Purple
- Ultramarine Blue
- Turquoise
- Phthalocyanine Green
- Payne's Gray
- Anthraquinone Blue

Gouache has a velvety, flat, opaque appearance when applied properly, but it can also be thinned to create watercolor-type effects.

Watercolor paint is sold in tubes, pans and half-pans. Tubes are creamy and wet, and pans are portable dried cakes of paint. You can also purchase empty pans of which ever size you prefer. Fill them with your own paints and allow them to dry. Gouache is not sold in cake format because it tends not to reconstitute well. My preferred M. Graham paints are made with honey, and they re-wet beautifully in both watercolor and gouache formulations. This allows painting on the go in both transparent and opaque approaches.

DECIDING WHAT PAINT TO USE AND WHEN

I love both the transparency of watercolor and the velvety, opaque appeal of gouache. But we are using these paints creatively and with abandon, so anything goes. If you dislike a page, use acrylic paints to obliterate or partially cover it. Or use acrylic paints as you see fit.

The manner in which I decide which paint to use depends on how I start the page. For example, imagine your first application is collaged paper applied with matte medium on watercolor paper. Knowing that matte medium need not cover the entire page, perhaps there is an area of the page that remains bare watercolor paper. The matte medium will affect the color intensity of watercolor paint, and you may still use gouache and acrylic paints on the page. Your options are open so long as you remain cognizant of what you have done thus far.

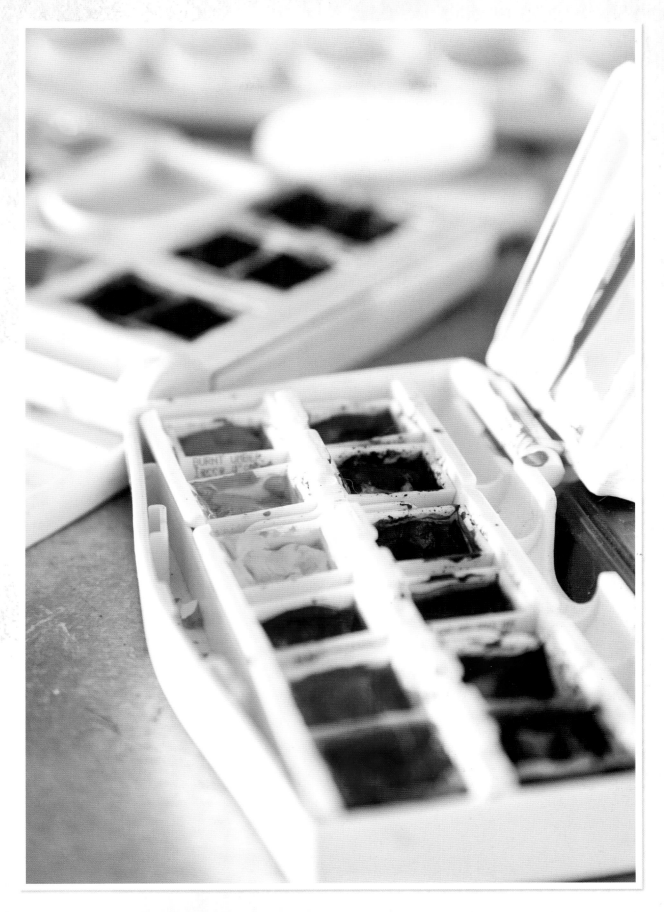

Pens, Pencils and Erasers

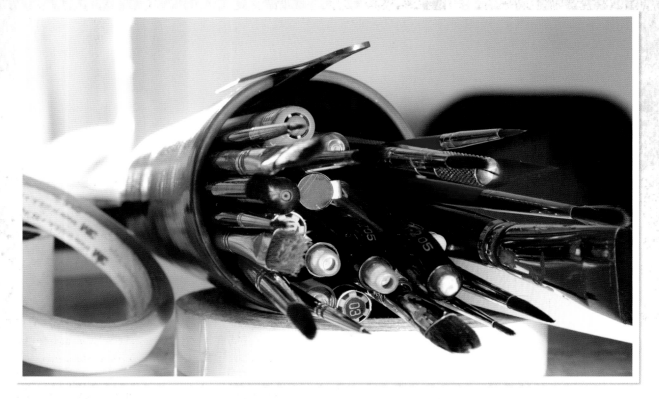

There are no certain or specific pens or pencils to be used in journalkeeping. I know artists who swear by the most basic ballpoint pens and others who need and love the latest flexible nib fountain pens and waterproof inks. Questions to ask yourself once you have found a pen whose mark you adore: Is this ink waterproof? Can I paint over it? Is the width of the mark acceptable? Do they sell this pen in other widths? Can I make scratchy marks? Can I achieve thicker lines by bearing down? Basically, you will want to thoroughly explore how you can and will use a specific pen in your work.

There are a few pens that I tend to use again and again. Micron sells felt-tipped markers that are strictly waterproof, come in various sizes, and although they will dry out if the caps are not replaced firmly, I find that each is a little workhorse of a pen. The Pilot P500 is an office-use pen that has an extremely fine tip, is waterproof and lasts a long time. On the water-soluble side, Pilot has office pens called the Precise V5 and V7. These pens bleed when water is applied to them, but I like to exploit this and spread the ink out to form shading. Uni-ball puts out a line of colored pens called Signo, and I cannot live without their white, gold and silver offerings. Pentel sells a cartridge-refillable Pocket Brush pen that I am head over heels for. The brush on this pen is made of actual bristles, and you can get beautiful thick and thin lines as if you were painting with, well, a brush. And because I like natural color, I also carry a Faber-Castell Pitt F sepia marker in my bag of tricks.

As for pencils, I swear by mechanical pencils and 3B leads because I can get a fine line without needing a sharpener. And the lead is soft and inviting. You may prefer a standard wooden pencil, appreciating the hexagonal wooden simplicity of it.

I also always keep two erasers close at hand. I use a Staedtler Mars plastic eraser, which is a good general purpose eraser. The kneaded eraser by Design allows you to press the eraser into the page and lighten without totally removing the mark. Pretty snazzy.

Try out my suggested pens, shop in both art supply and office supply stores, and don't discredit any pen until you test its worthiness in your own artistic pursuits. This is your journaling practice; make it work for you.

Brushes

You will need an array of brushes, from the cheapest foam and bristle brushes to beautiful watercolor brushes. If you choose to work in acrylics, you should also purchase brushes specific to that task. The ferrule (the metal area just above the bristles) of a brush holds the bristles together and attaches them to the handle. Paint and pigment can get trapped in this area, and you do not want it to dry and ruin your brush, or worse, release pigment where you do not intend it to be released. I'd suggest leaving at least the ⅛" (3 mm) of bristles nearest the ferrule clean and paint-free.

Your best brushes should be stored with care and attention. I store mine in a sushi roller retrofitted with elastic strips. Art supply stores carry an array of options for this purpose, too. And do not float your brushes in your wash cup; this will allow water into the ferrule and will weaken the paint or finish applied to the handle. The bristles will become brittle and splayed. Watercolor brushes can be quite expensive, but treated with care, they can last a long time. My best brushes are fifteen years old and still snap to a precise point.

In choosing watercolor brushes, there are many considerations. If you want to paint on the go, waterbrushes are your best bet. These brushes have a water well within them and a valve that prohibits paint from being sucked into the well. These features ensure a clean water source.

If you are a vegan or otherwise concerned with the welfare of our fellow creatures, you will want to invest in the best synthetic brushes available. Otherwise, you might consider the best Kolinsky Sable brushes the market has to offer. The choice is yours.

Quality art supply stores will allow you to wet a watercolor brush to see if the bristles come to a sharp point when wet. Another indicator of a good brush is to is to drag it off the edge of your finger. The bristles should spring back to a tight, sharp point. Brushes with misaligned or splayed bristles should be avoided. Because quality brushes can be quite an investment, you might start off with sizes #0 and #6, filling in with other sizes and shapes as your budget allows. One tip that really made an impression on me in school was that you should be able to use the tip of a quality #8 watercolor brush to achieve a line akin to using a #1 brush. This is good to aspire to and easier on your wallet!

I allocate saving brushes that have reached the end of their natural lives for use with acrylics. Because acrylic paints are plastic in nature, it is necessary to keep separate brushes for use with them. I do not want a buildup of acrylic paint in the bristles of my watercolor brushes, and I keep fewer acrylic brushes in my arsenal than watercolor. I find a 1" (3 cm) square brush, sizes #1, #4, and #8 round and a size #3 filbert to be sufficient.

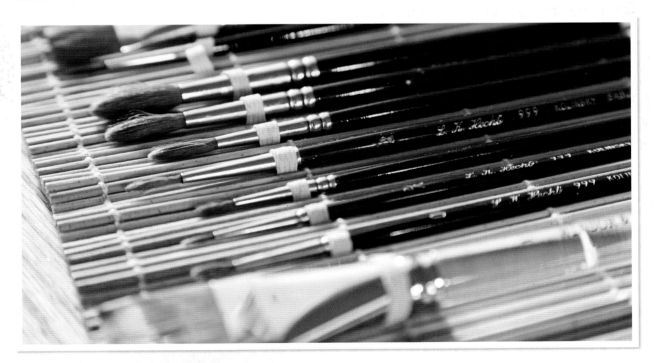

Glues and Other Useful Items

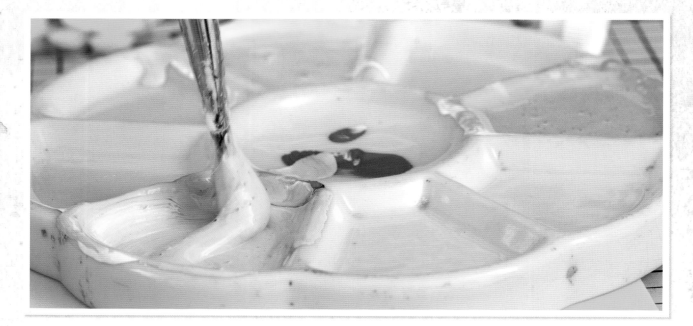

You will want to keep a few different types of glue on hand.

Matte medium serves as an all-purpose glue; simply spread matte medium on your page, place your collage materials on top of the medium, and allow it all to dry. Watercolor and gouache paints will release pigment when matte medium is applied atop it. This is not necessarily a bad thing, but rather an artistic approach to using a mixture of media. Matte medium will also change the solubility of watercolor paper, which can create very interesting effects.

My second-favorite glue is the simple glue stick. Look for only the creamiest, softest formulations. I rely on glue sticks when I want to maintain the integrity of the watercolor paper in my journals.

And as for other useful items, here are just a few:

When I paint at home, I use porcelain mixing palettes because porcelain does not stain and even acrylic paints will lift completely away off the surface of the palette. On the go, you can mix paints in the lid of your watercolor or gouache palette, and if it is important that the palette remain clean and white, you might scrub the lid with a toothbrush and powdered bleach.

A heat gun is useful in speeding up the drying time of most paints and mediums, though not all. Liquid frisket will bubble and lift off the page, and it much prefers to be allowed to dry naturally.

Keep a dropper bottle nearby. As you mix paints, this will help with both consistency and hue.

A small bucket or yogurt cup filled with water will help in quickly rinsing your brushes.

Rags or towels are always useful in sopping up excess water from your brushes while you paint.

TIPS!

• A basic rule of thumb for any glue application is to apply the glue on the sturdier of the two papers you are working with.

• Matte medium can also be used to seal transient applications like pencil, colored pencils and some chalk pastels. Use caution and a dry—not soupy—application of the medium.

Pairing Cloth and Paper to Techniques

We will be using a plethora of media in this book: kozo, kinwashi, tracing paper, cotton broadcloth, silk velvet and silk organza. Some can be painted, others dyed, some can be stamped, stenciled or drawn on with a ruling pen. Your job is to experiment and learn the qualities of each so that you can pair a technique to a planned outcome.

Learn to evaluate the properties of each item you choose to use. For example, kinwashi is a sheer paper made of mulberry, which has gorgeous fibrous inclusions. Compared to 90 lb. or 140 lb. watercolor paper, kinwashi is diaphanous. When used with soy wax and paints you will want to pair this paper to a transparent acrylic paint that will show off the inclusions beautifully. Kinwashi is so sheer that portions of the paper that

remain unpainted will show off the layers of journal page beneath. This transparency might not be as effective as with tracing paper, but tracing paper cannot boast such gorgeous inclusions.

Question your intentions for your materials. Does the fabric need to be washed? Will slubs interfere when printing with a beautiful handcarved stamp? Will the nap of the velvet accept fine lines when used with soy wax batik? Doing a sample run of an idea before making a commitment with your fabric or paper is tantamount. A compatibility chart follows, but I encourage you to record your findings every step of the way. When you work in this way you will be able to revisit your notes and you will become your own best teacher.

 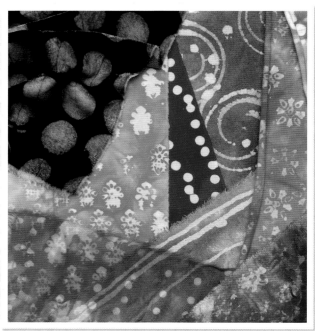

Cloth or Paper?
SOY WAX TECHNIQUES CAN BE USED ON BOTH PAPER (LEFT) AND CLOTH (RIGHT) WITH DIFFERING RESULTS.

FABRIC/PAPER COMPATIBILITY CHART

Fabric or Paper	Paint or Dye	Rubber Stamp	Fun Foam	Ruling Pen	Freezer Paper	Stencil	Tracing Paper	Soy Wax	Paper Frisket	Liquid Frisket
Cotton Broadcloth	T, O, D	●	●	●	●	●		●	●	
Silk Organza	T, O, D	●	●	●	●	●		●	●	
Silk/Rayon Velvet	D	●						●		
Knit Jersey	O, D	●	●	●	●	●		●	●	
Silk Noil	D					●		●		
Kinwashi	T	●	●	●		●		●		
Kozo 203 (# specific to store purchased)	T	●	●	●		●		●		
Tracing Paper	O	●	●	●		●		●		
Newspaper	O	●	●	●		●		●		
Watercolor Paper	G, W	●	●	●		●	●		●	●

PAINT/DYE KEY

T = transparent

O = opaque

G = gouache

W = watercolor

D = dye

2

Color: Get to Know It

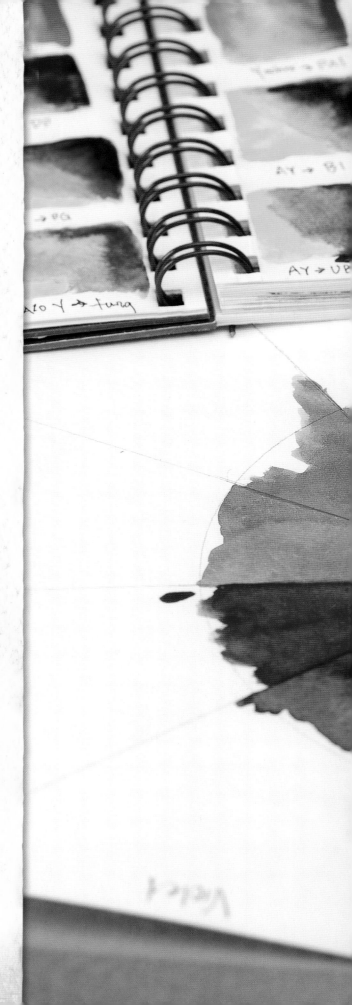

In this chapter, we will explore simple and approachable ways to gain experience with the colors you invite into your art bin. Really, all that needs to happen is for you to roll up your sleeves and allow yourself to dirty up a few pages. In the process, you will get to know the properties and mixing possibilities of the colors at your fingertips.

Truly, learning to use color is about forming a relationship with the colors you have at your disposal. You need to understand what will happen when you add white or, in the case of watercolor, water to a color. You need the experience of adding a color's compliment, and you need to know how to darken, brighten and mix specific colors. This adventure requires your full participation.

A few basics: Primary colors (red, yellow and blue) cannot be mixed using any other color. Secondary colors are mixed using two primary colors; tertiary colors are mixed by using three colors, including both primary and secondary colors. It is in learning to mix tints, tones and shades that the magic begins.

Using a limited palette helps you by pinpointing your knowledge base to specific colors. In forming relationships with color, we need to apply concepts and ideas to the colors we work with. Are you working with a warm or a cool blue, for example? Does this color lean toward yellow or blue? Yellow is warm; blue is cool. Turquoise is a warm blue, while cobalt is a cool blue.

It may seem obvious, but yellow is the lightest color in the color wheel, and, as such, it is the most easily influenced color. You will need to use caution so you do not overwhelm the yellows you mix, and yellow will be the color you will replenish most often.

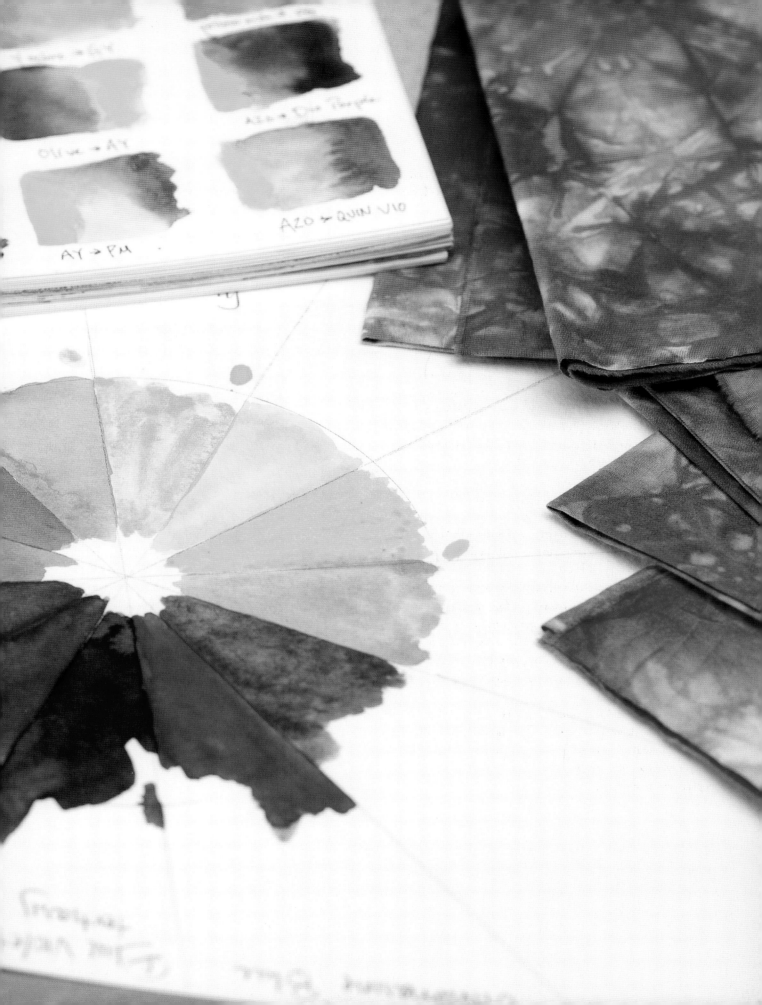

Color Tabs

This is the first and easiest way to get to know your colors. It is best if you make a single chart for each type of paint you plan to use: watercolor, gouache and acrylic. Simply swipe paint directly from the tube, wetted pan or jar onto a strip of paper, making sure you swipe the paint all the way off one edge of the paper. Label each color according to the bottle or tube. These swiped color tabs will help you grab the color that is just right for your next project or idea.

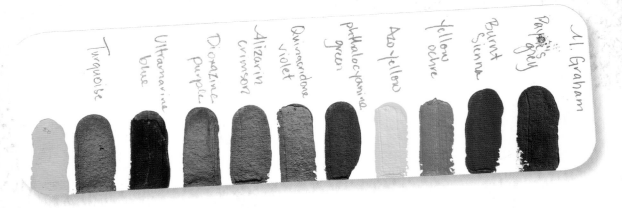

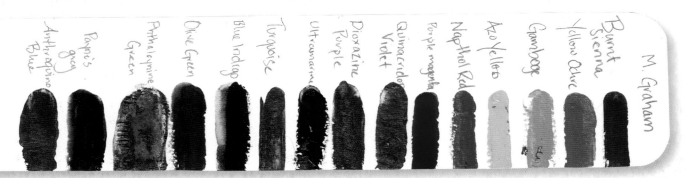

Gather This:

- 140 lb. watercolor paper cut into 2" (5cm) strips—one for each type paint you will use

- Paint

- Pencil or pen

1. Group similar hues together.

2. Swipe paint off one edge of the watercolor paper.

3. Label each color according to the paint label.

TIP!

Keep this chart nearby as you get to know your paints. If you need an earthy yellow, you will be able to check your tabs, then reach for Yellow Ochre.

Learn About Color in 20 Minutes or Less

If you hold a blue flashcard in your hand and show it to twenty people, then put the card away and ask each person to describe the color, you will get twenty totally different responses. One person will describe the blue as having a smidge of yellow, while another might call the same color ultramarine. Painting clouds can be one of the most difficult things an artist will face because there are so many shades of white. You will also find that placing one shade of blue along side another will influence each color respectively.

Gather This:

- *Magazine*
- *Scissors*
- *Glue*
- *Journal*

I suggest you do this exercise in 20 minutes or less—do not over think any of this!

Choose a basic color, like blue, and cut snips and chips of any sort of blue you find within the pages of magazines, ads, flyers, catalogs, whatever. Light blue, dark blue, sky blue. Even if an image has a tinge of blue, cut and glue it onto the page, without leaving space between your cut pieces.

Once your page is complete, look at it and ask yourself: Are all of the snips and chips blue when compared to their neighbors?

Of the snips that now look "off," evaluate what made you choose that color in the first place, and determine if it is blue after all.

The Color Wheel

Learning to use and mix color effectively is essential to your ability to express yourself as an artist. It is both an adventure and a challenge, one that I hope you will engage in with abandon. Learning to mix color can be daunting; muddy and dull colors will surface, but there are a few tips that will help you along.

When you purchase paints, I suggest you choose professional grade paints that clearly list pigment names on the side of the bottle or tube. If you have been purchasing craft or student-grade paints, you may not be aware that paints are made with specific pigment names. In my watercolor color wheel, I have used Napthol Red, Azo Yellow and Ultramarine Blue (the pigments listed on these tubes are Napthol AS-D [PR112], Benzinidazalone Yellow [PY 151] and Silicate of Sodium with Sulpher [PB 29], respectively).

I have chosen to use M. Graham watercolor paints for this demonstration, and I mention this because each formulation of Napthol Red from each manufacturer uses different pigments and formulations, all of which affect the color you see. I suggest you use single pigment paints so that you can learn the characteristics of each color and acquire knowledge about how each interacts with its fellow colors in your watercolor box. In general terms, some craft paints are a mixture of pigments and can also contain interference powders, which give them metallic and halo effects. As a result, this type of paint does not mix well, but is pleasing in its own right for its intended purpose. This also further illustrates my reasoning for choosing single pigment paints: If you try to mix clean colors with unknown mixtures of pigments, frustration will result. So choose your paints, pigments and formulations with your end goal in mind.

Primary colors—red, yellow and blue—cannot be mixed from any other color. Secondary colors are a mixture of two primary colors, and tertiary colors are a mix of three colors. When choosing three colors to make your own color wheel, you will want to choose three primaries that have a relationship to one another. For instance, you might choose three primaries that appear "cool," noting that cool colors tend toward blue and "hot" colors tend toward yellow. Learning to evaluate the tenor of each color you see is part of the process of learning to mix color.

When I was in school for textile and surface design, I was taught never to darken a color using black, as black will only dull the color. Using a color's complement will both darken the color and enliven it to vibrate with intensity. I was also taught to mix no more than three colors in any given mixture, again for fear of muddying the mix. To this day, I fully accept this reasoning, and my knowledge is backed by experience.

Remember, yellow is the lightest color in the color wheel and is easily overwhelmed. But you will use more of it than any other color. When mixing greens and oranges, start off with a majority of yellow and slowly add red or blue, so that you attain effective results.

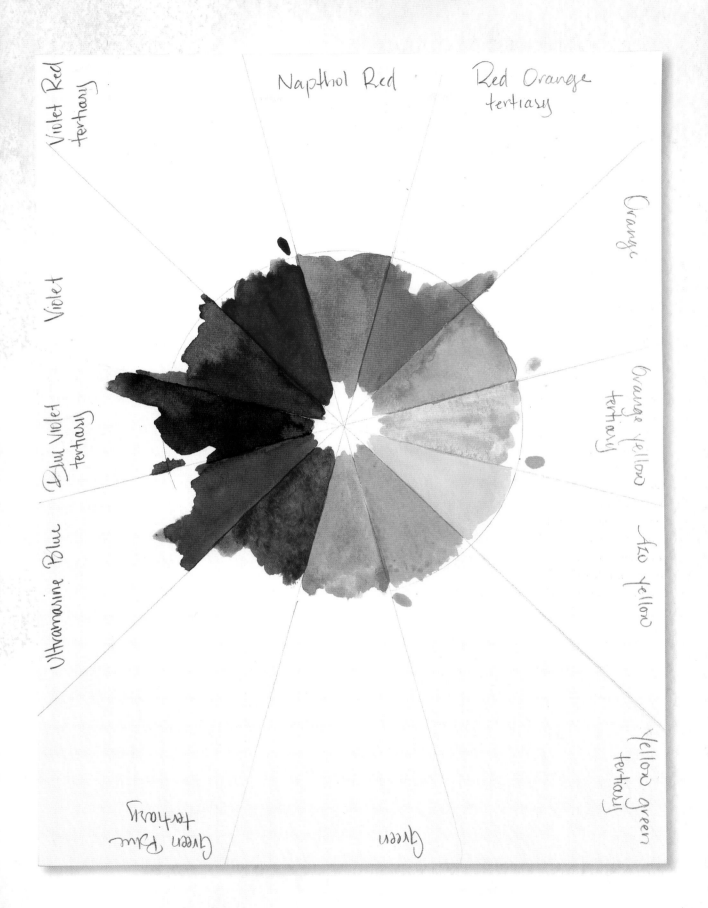

Violet Red
tertiary

Napthol Red

Red Orange
tertiary

Orange

Violet

Orange Yellow
tertiary

Blue Violet
tertiary

Azo Yellow

Ultramarine Blue

Yellow green
tertiary

Green Blue tertiary

Green

Mixing Your Own Color Wheel

One of the first steps in mixing color is to mix your own color wheel. After all, what better way to gain experience than by doing it yourself? Give yourself a huge pat on the back and star your page when you complete your color wheel. (And remember you can and should do a color wheel with each of your chosen paints, gouache and acrylics, too.)

Gather This:

- *Watercolor paper*
- *Pencil*
- *Paint palette*
- *Watercolor paints*
- *Bucket with clean water*
- *Paintbrushes*

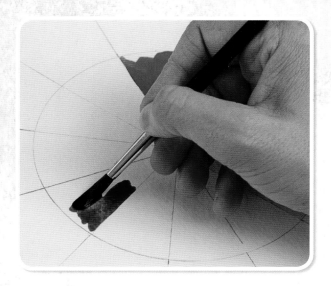

To begin:

Draw a circle on watercolor paper and then divide the circle into twelve equal parts.

Primary Colors:

Wet red watercolor and paint at 12 o'clock, yellow at 4 o'clock and blue at 8 o'clock.

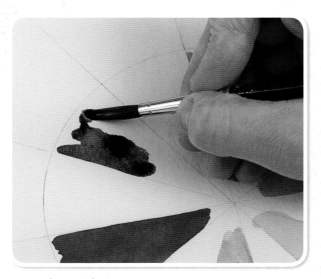

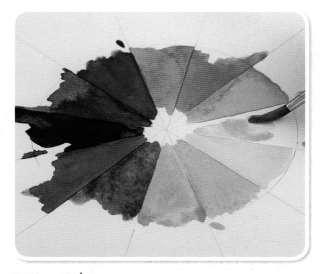

Secondary Colors:

Make sure to mix extra quantities of these secondary colors for use in mixing the tertiary colors.

- Mix red and yellow watercolors together to make orange (remember to use a bit less red than yellow), and place the orange paint at 2 o'clock.
- Mix yellow and blue watercolors together to make green (remember to use less blue than yellow), and place the green paint at 6 o'clock.
- Mix blue and red watercolors to make violet, and place the violet paint at 10 o'clock.

Tertiary Colors:

Mix the secondary colors previously mixed with the primary colors as directed below. Make sure you keep the mixed secondary colors as clean as possible in the palette wells.

- Mix red with orange to create red-orange, and place at 1 o'clock.
- Mix red with violet to create red-violet, and place at 11 o'clock.
- Mix yellow with orange to create yellow-orange, and place at 3 o'clock.
- Mix yellow with green to create yellow-green, and place at 5 o'clock.
- Mix blue with green to create blue-green, and place at 7 o'clock.
- Mix blue with violet to create blue-violet, and place at 9 o'clock.

Dry-on-Dry Watercolor Explorations

Working dry-on-dry with watercolor paints means that you allow each layer to dry between applications. If you are impatient, like me, you can use a heat gun to dry each layer. When I work this way, I like to mix my palette beforehand and try it out just to see that my color choices work. Do not hesitate to work a palette out on scrap paper (or cloth), and every sample you create should be stored in a three-ring binder or supportive journal so that you can look back and learn from your experience.

Gather This:

- Watercolor paints
- Watercolor paper
- Paintbrushes
- Palette
- Bucket of water
- A well-thought-out design

About Watercolor Paper

Paper is sold by weight, and this is an indicator of both density and thickness. For example, you will hear paper described as 90 lb., 140 lb. or even 300 gsm (grams per square meter). My preference is for 140 lb. cold- or hot-press papers. Setting the type of paper aside, I prefer a heavier paper that will not curl, as some 90 lb. papers have a tendency to do. Heavier weight papers can withstand collage and acrylic paint applications, and they work well as they were originally intended, as watercolor papers. The terms cold- and hot-press refer to the finishing technique of the papers. Cold-press papers have a rougher texture than hot-press papers, which look and feel much smoother. All watercolor papers have sizing in them; sizing helps the paint pool atop the fibers of the paper, allowing you to move the pigments of the paint over the surface of the paper before they slowly settle in and dry. My current fickle and oft-changing preference for paper is for 140 lb. hot-press watercolor paper. I encourage you to experiment with the papers you find at your local art supply store. Take notes and come to your own conclusions.

1. Mix a limited palette of colors; in this example, I used four colors. Paint your first and lightest color, and allow the paint to dry.

2. Remember to leave the "light" spots. White tends to leap off the page, and the smallest bit will carry a lot of weight. Paint your medium color(s). Allow the paint to dry.

3. Your darkest color also carries weight. Learn to foster your intuition, compare what you see and apply your darkest colors accordingly. Allow the paint to dry.

4. Shadows always fade out, so I chose to apply the shadow as a wet-on-wet application.

 TIP!

Always work from light to dark.

Wet-on-Wet Watercolor Explorations

Learning to use watercolor is the adventure of a lifetime. Allow yourself time to make joyous mistakes, trusting that you will gain knowledge and perhaps even sometimes disappoint yourself. It is all part of the learning curve; push paint, one color into another, flood the area with water and lighten the pigment on the page. Watch what happens and at the same time you will gain experience. You can read every word printed in a book, but it is only by doing that you will learn.

Working wet on wet is a fun way to mix watercolors on the page. Basically what this means is that you will flood an area of the page with water (akin to painting a puddle of water on the page). Load a watercolor brush full with a single color and apply it to perhaps the left half of the puddle. Rinse, then load your brush with another color and apply the paint to the right half of the puddle.

You will see that the pigment has a mind of its own and will branch and feather into the middle of the puddle and begin to mix of its own volition. The puddle of water and paint can now be played with, mixed, moved and altered. This will work until the water seeps into the paper itself and you find that the pigment no longer wants to move.

What makes this magic occur? Sizing. Watercolor papers are treated with sizing to slow the absorption of water into the fiber of the paper. So when you see a nice domed puddle of water on your paper, you know that it has been sized to accommodate your needs as a watercolor artist.

I have drawn a simple bird shape and dissected it into four distinct shapes to illustrate the process. When working this way, allow each area to dry completely before moving to the next section. A heat gun can assist in drying if need be.

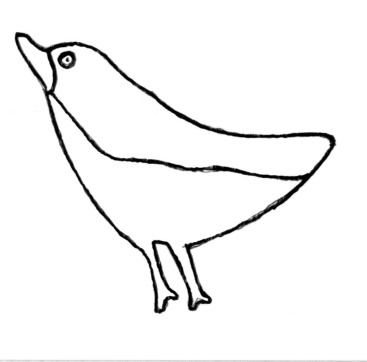

Gather This:

- Watercolor paints
- Watercolor paper, 90 lb. or higher
- Watercolor brushes
- Bucket with clean water
- Pencil
- A simple drawing with a few sections (use mine!)
- Heat gun

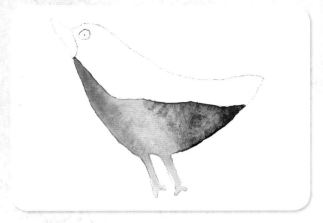

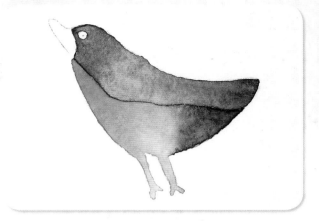

1. Outline a simple drawing on watercolor paper. Flood an small area of the paper with water. Apply two colors of paint to the flooded area, one at each end of the bird's body. Mix and blend the two colors together with a paintbrush. Allow the paint and water to dry.

2. Flood another area of the watercolor paper (for the upper body of the bird) with water. Once again, apply two different colors, one at each end of the bird's body. Mix and blend the colors together. Allow the paint and water to dry.

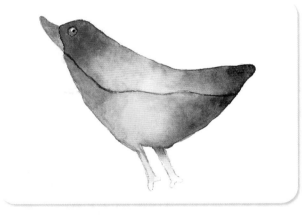

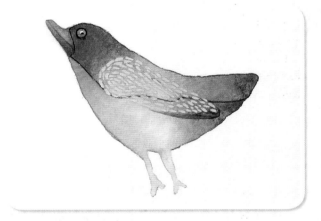

3. Paint the beak and eye.

4. To extend the fun, my sample also uses gouache to create a wing. I painted a teardrop shape and added soft dashes. So simple! I also used a circle template to round out the eye.

TIP!

If you want to avoid the fuss of flooding the upper part of the bird's body around its eye, try using a liquid frisket (see Chapter 3, The Techniques).

Low-Water Immersion Fabric Dyeing

Low-water immersion dyeing is aptly named, using a small amount of color mixture, a small container, tightly bundled cloth, soda ash and little or no stirring. Low-water immersion dyeing creates a more artistic or mottled effect on cloth. We will be using low-water immersion dyeing as an entry into the wonders of dyeing your own fabrics. What I share here is just the tip of the iceberg in terms of the possibilities of the media.

PROCION MX DYES

Procion MX reactive dyes dye primarily cellulose fibers—plant-based fibers like cotton, linen, ramie, hemp, viscose rayon, bamboo and even silk—at room temperature, 75 degrees to 95 degrees Fahrenheit. These are called reactive dyes because when they're combined with soda ash and cloth, a chemical reaction occurs within the fibers of the cloth, coloring the entirety of each fiber. The majority of the reaction occurs within the first fifteen minutes that the dye, fiber and soda ash are in contact with one another.

The nine colors available from most dye manufacturers offer a balanced palette. If you were to pick one color grouping—for example, the Pop! grouping from MX Dyes—you will have three great colors to begin your cloth dyeing voyage.

MX DYE CHART

Procion MX Reference Name/Number	PRO Chemical & Dye Name/Number	Dharma Trading Co. Name/Number
Pop! Yellow MX-8G Magenta MX-5B Cobalt Blue MX2G-150	Sun Yellow 108 Fuschia 308 Turquoise 410	Lemon Yellow PR1 Fuschia Red PR13 Turquoise PR25
All Around Goodness Bright Golden Yellow MX-3RA Magenta MX-5B Cerulean Blue MX-G	Golden Yellow 104 Mixing Red 305 Intense Blue 406	Deep Yellow PR4 Light Red PR12 Cerulean Blue PR23
Get Earthy Lemon Yellow MX-8G Bright Scarlet MX-BA Navy MX-4RD	Tangerine 112 Strongest Red 312N Deep Navy 414	Golden Yellow PR3 Chinese Red PR10A Navy Blue PR24

DYE MIXTURE/YARDAGE CHART

¼ yard cotton	½ yard cotton	¾ yard cotton	1 yard cotton
¼ cup dye mixture	½ cup dye mixture	¾ cup dye mixture	1 cup dye mixture
¼ cup soda ash	½ cup soda ash	¾ cup dye mixture	1 cup soda ash

FIXATIVE

Soda ash is an alkali that activates the bond between Procion MX dyes and cellulose fibers, cotton, linen, rayon, Tencel and the like. Luckily for us, Procion MX and soda ash will also dye many types of silk, organza among them. Experimentation and an inquisitive approach will go a long way in your mixed media adventures.

Soda Ash Recipe:

$\frac{1}{2}$ cup soda ash
1 gallon water
shake vigorously

SYNTHRAPOL OR DHARMA PROFESSIONAL TEXTILE DETERGENT

Synthrapol and Dharma detergents work to isolate dye particles and draw them away from your beautiful cloth. Putting a teaspoon of detergent in a low-water immersion bath will also help you obtain a less mottled dye effect. This is called leveling.

When washing the excess dye from your cloth, soak the cloth in cold water. Dump the water and replace it several times until it runs clear. Once the water runs clear, wash the cloth with Synthrapol or Dharma detergent.

DYE CONCENTRATE

Think of dye concentrates as you might think of tubes of paint, and keep them pristine and ready for action. You will use your concentrates to mix secondary and tertiary colors (also called dye mixtures). You can achieve beautifully subtle color mixtures by using mere drops of concentrate to the appropriate water-to-cloth ratio, or you can go for the gusto and add as much as three or four tablespoons of concentrate to that same amount of water, and you will be fusing vibrant, richly saturated hues in no time.

Dye Concentrate Recipe:

200 milliliters water
2 tablespoons dye powder
2 tablespoons urea to help the dye absorb into the cloth

UREA (OPTIONAL)

Urea is a synthetic nitrogen compound used as a humectant, a substance that helps fiber or cloth absorb or retain moisture. Urea helps the dye, cloth and soda ash mixture remain as wet as possible for as long as possible, and this, in turn, helps you achieve the brightest colors possible.

BATCHING

To batch means you allow the cloth, soda ash and dye mixture to sit and react in the chemical environment you have created for it. After this passive treatment, you can wash the cloth with detergent, dry it and use it.

TIP!

When mixing color mixtures from dye concentrates, cut a white paper towel into small strips. When you think you have mixed a great color, dip a piece of the paper towel into the mixing cup to guesstimate your eventual outcome.

Two-Color Gradation

When mixing color, you will notice that blue can overwhelm most easily, as it is the darkest color available to you. Yellow, being the lightest, can get buried in the color-mixing process because it is the lightest color in the wheel. Mixing color is an adventure, an experiment you will benefit from participating in.

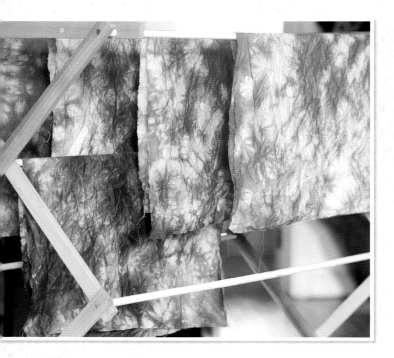

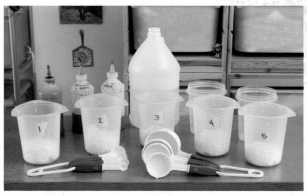

Gather This:

- 5 fat quarters of cloth
 (18" × 22" [45.72cm × 55.88cm])

- 5 one-quart containers

- 1 one-gallon container

- 3 funnel-tipped jars

- Measuring cups and spoons

- Masking tape

- Marker

- Gloves

- Apron

- Several one-gallon zip-top bags

- Large bucket or tub (for rinsing)

Safety First!

When handling dye powders, soda ash, urea or most any art supply, you must take precautions to ensure your health. Read labels thoroughly, seek out Materials Safety Data Sheets (MSDS) for all products in your studio and use the information. Wear a dust mask when you handle dye powders and auxiliary chemicals. Use a gas mask if you use noxious chemicals, or, better yet, don't use them at all. Finally, protect your hands by wearing nitrile gloves.

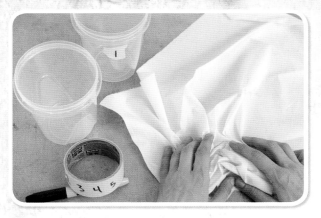

1. To dye five fat quarters in gradation, label each of five one-quart containers as #1 through #5 and place one fat quarter in each container.

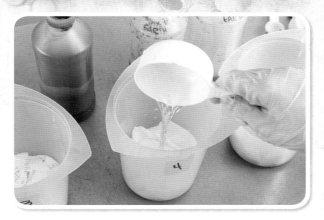

2. Pour ¼ cup of soda ash over each fat quarter, and allow the fabric to soak for fifteen minutes or more. Mix each of two dye mixtures into 1 ¼ cups of water (see dye Mixture/Yardage Chart). Place one color to the right of the row of quart containers and one to the left.

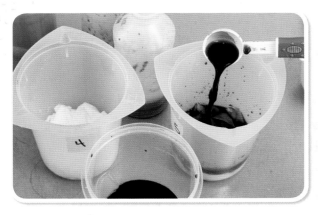

3. Then, working from left to right, measure eight tablespoons of the first dye mixture into quart #5, four tablespoons into quart #4, two tablespoons into quart #3 and one tablespoon into quart #2.

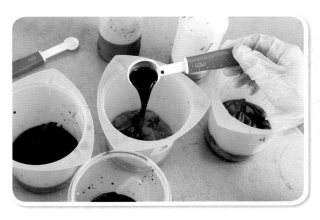

4. Then working from right to left, measure eight tablespoons of the second dye mixture into quart #1, four tablespoons into quart #2, two tablespoons into quart #3 and one tablespoon into quart #4.

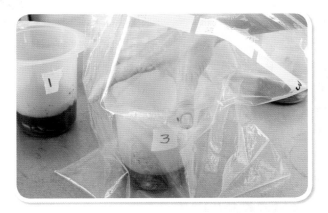

5. Place each one-quart container in a zip-top bag and batch for 4 to 48 hours.

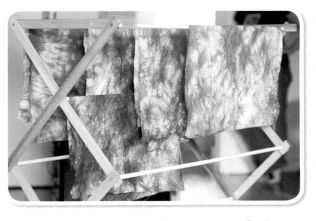

6. Remove the fabric from the containers. Soak, wash and allow the fabric to dry.

Bonus Skillbuilder: Hand-Dyed Color Wheel

I used the All Around Goodness colors to create the samples you see here. I suggest you work with your favorite colors so that you get the best and most exciting samples possible.

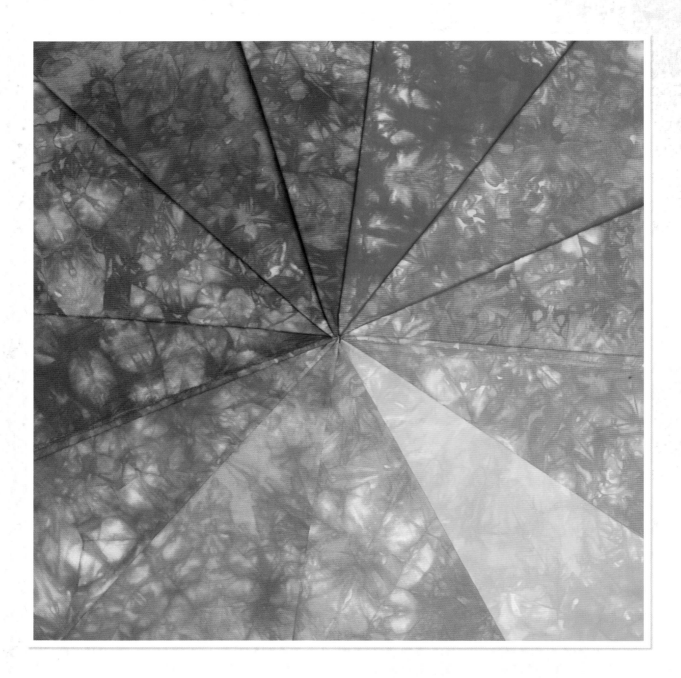

Mix 4 tablespoons Golden with 1 cup water. From that measure/combine:	Mix 4 tablespoons Mixing Red with 1 cup water. From that measure/combine:	Mix 4 tablespoons Intense Blue with 1 cup water. From that measure/combine:	Color Mixtures	Container #
	8 **tablespoons**		Mixing Red	1
1 **tablespoon**	4 **tablespoons**		Red-Orange	2
2 **tablespoons**	2 **tablespoons**		Orange	3
4 **tablespoons**	1 **tablespoon**		Yellow-Orange	4
8 **tablespoons**			Yellow	5
4 **tablespoons**		1 **tablespoon**	Yellow-Green	6
2 **tablespoons**		2 **tablespoons**	Green	7
1 **tablespoons**		4 **tablespoons**	Blue -Yellow	8
		8 **tablespoons**	Intense Blue	9
	1 **tablespoon**	4 **tablespoons**	Blue-Red	10
	2 **tablespoons**	2 **tablespoons**	Purple	11
	4 **tablespoons**	1 **tablespoon**	Red-Blue	12

Gather This:

- 12 fat quarters of cloth
 (18" x 22" [45.72cm x 55.88cm])
- 12 quart containers
- Dye concentrates
- Soda-ash solution
- Mixing cups
- Measuring spoons
- Gloves
- Apron

1. Place one fat quarter in each numbered quart container.

2. Pour ¼ cup soda-ash solution over each fat quarter.

3. Follow the above chart to add dye mixtures to numbered containers

4. Agitate the cloth often during the first 15 minutes; compare the resulting colors to the gradation dyed goods.

5. Batch, soak and wash the fabric and allow it to dry.

3

The Techniques

Techniques are tools that are used to annunciate and bring forth your unique visual perspective. I suggest you begin by trying each idea out while taking notes directly on your samples; don't assume you will remember what you did in weeks or years to come. When you take the time to integrate ideas into your artistic approach, you will make connections of use and potential. In later chapters, we will combine the techniques learned. For now, take it one tool at a time.

Carved rubber stamps can be extremely detailed with an expressive quality that cannot be achieved through any other means. Fun foam, on the other hand, has a playful sense of immediacy and can be used to create multicolored stamps, multiplying the fun exponentially.

Stencils are another fascinating way to help the imagery in your journal leap off the page and into the world. Stencils have a fine tradition of use in street art, home decor and the culinary arts. Applying yourself to creating a library of stencils is a worthy goal, and will contrast and combine nicely with any commercial stencils you may have in your stash.

Tracing-paper overlays are a quick and fun way to add dimension to a journal page and also have a direct correlation when working with cloth. Silk organza is transparent in the same way as tracing paper; combine that with some paint and a ruling pen, and you can begin drawing and painting on the organza to create overlays for your painting and mixed-media adventures.

Resists or masks help you reserve or preserve an area of your work. When working with watercolor paper, you can use frisket—either paper or liquid; temporary masking tapes do a similar job. When working with cloth, you can use either soy wax or freezer paper and achieve similar results. Using resists helps you add pop and sparkle to your pages, paper and cloth.

In combination, these techniques yield fantastic results, so take the time to learn the intricacies of each approach, and you and your art will benefit by leaps and bounds.

...chbird, range du ...
...gurea

...tched velvet

...roll T, green tjap b...
...a, striped blue noil

... stripe ... cotton, dotted

Spanul?

Solid Grounds

Creating a solid ground or wash using watercolor is quite easy, requiring few tools and little time. Combine a solid ground with either liquid or paper frisket and your page will come to life that much more quickly. You can paint the ground first or use paper or liquid frisket to preserve a previous application to the page. Testing an idea out is always a good idea.

Gather This:

- *Journal page*
- *Wide-bristle or foam brush*
- *Watercolor or extremely thin acrylic paint*
- *Spray bottle with water*
- *Palette*
- *Bucket*
- *Heat gun (optional)*

1. Mix more color than you think you will need.

2. Spritz the page evenly.

3. Brush horizontally across surface of the page.

4. Assess where the paint is pooling and brush vertically to smooth and distribute color.

5. Allow the page to dry or use a heat gun to move the process along.

Gradations

Gradations are created in much the same way as solid grounds, except you will paint two separate colors, which will mix and meld somewhere between the two applications. To create a gradation, you must work quickly. Prepare for this by placing all your tools, brushes, spray bottles and paint mixtures at the ready. You may need to spray the page to freshen the paper's absorbency, or you may wish to add more of one or both colors. Play with the concept in order to perfect it.

Gather This:

- *Journal page*
- *Wide-bristle or foam brushes*
- *Palette*
- *Watercolor or extremely thin acrylic paint*
- *Bucket*
- *Heat gun (optional)*

1. Mix two colors.

2. Spritz the page evenly and be prepared to work quickly.

3. Apply one color on top of the page and feather this color downward. You may need to slightly wet the brush to lessen the amount of paint in the brush.

4. Rinse the brush thoroughly, apply the second color to the bottom of page, and rinse some, but not all, of the paint from your brush. Feather upward and into the first color application.

5. Allow the page to dry or use a heat gun.

Resists: Liquid Frisket

Liquid frisket is known by several names: masking fluid, liquid mask and liquid frisket. It's a rubber-like substance that can be painted onto the surface of most papers, allowed to dry naturally, painted over, and removed with the use of a rubber cement remover. The rubber nature of the frisket will ruin the brush used to apply it, so if you have old brushes that you are willing to dedicate to use with liquid frisket, here is a trick that will extend the life of the brush: watered-down liquid soap. Dip your brush into watered-down soap just prior to dipping it into a well of liquid frisket. Wash your brush out periodically and the bristles will remain available to the task for much longer than if you had not used the soap.

Otherwise, invest in The Incredible Nib. The Incredible Nib and other such tools, while not absolutely necessary for working with frisket, are manufactured specifically to the task.

TIPS!

• Liquid frisket is notorious for drying out well before you reach the bottom of the bottle. To make yours last longer, always store liquid frisket upside down, so that no air can penetrate the seal of the bottle. Pour a small amount into a well prior to use and cover the bottle as soon as you can.

• Allow liquid frisket to dry naturally. Liquid frisket is akin to rubber, and drying it with a heat gun will force it to bubble and lift off the page. This breaks the bond between frisket and paper and allows paint though the mask. Given these odd quirks, liquid frisket is an awesome means to reserving an area of your painting. Learn its quirks and it will be an indispensable masking tool.

• It is a good idea to remove the liquid frisket from your paper as soon as possible.

Gather This:

- Water
- Paintbrush or The Incredible Nib
- Liquid frisket
- Palette or paint well
- Watercolor paper
- Watercolor paints
- Rubber cement remover
- Liquid soap

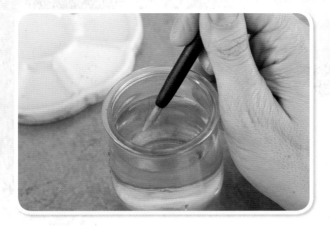

1. Wet The Incredible Nib.

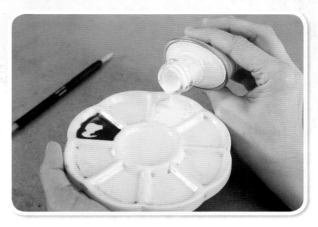

2. Pour a small amount of liquid frisket into a well.

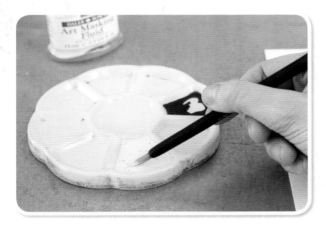

3. Dip the nib into the liquid frisket.

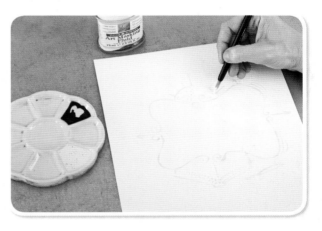

4. Apply the liquid frisket to watercolor paper and allow it to dry naturally without the use of a heat gun.

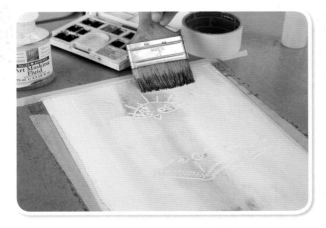

5. Paint over the liquid frisket.

6. Once the paint is dry, use a rubber cement remover to lift the liquid frisket off the page.

Resists:
Matte and Semigloss Mediums

There are benefits to working with both acrylic and watercolor paints on watercolor paper. When you use either matte medium or semigloss medium on watercolor paper, it forms an impenetrable area on the paper. Once it's dry, you can paint right over the medium and it will form a resist. Matte medium is a bit more subdued than semigloss and leaves behind a tone-on-tone quality, whereas semigloss medium creates more of a window into the previous layers of paint.

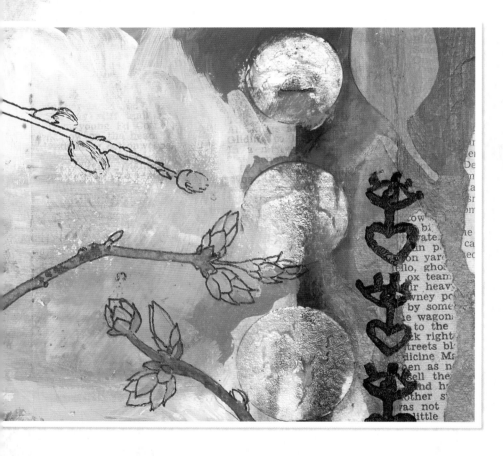

Gather This:

- *Watercolor paper*
- *Regular gel semigloss medium or matte medium*
- *Palette*
- *Acrylic paintbrush*
- *Watercolor or gouache*
- *Bucket of clean water*

Exploit Interesting Effects: Watercolors and Acrylics

Given the nature of the two media (one water soluble, the other a plastic), interesting effects will surface when they are used in combination on watercolor paper. You can (and should) read labels and follow the rules, but you can also dribble semigloss medium over watercolor paper, allow it to dry, and then paint a wash of transparent watercolor atop that.

This works because acrylic mediums, when applied to watercolor paper and dried, seal the fibers of the paper shut; watercolor paints glide over but cannot fully adhere to the plastic medium. The unaffected paper is just as absorbent as it has always been and accepts watercolors eagerly. Both matte and semigloss medium take watercolors differently, and they also reveal prior layers differently.

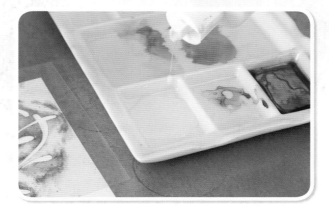

1. Pour a small amount of matte or semigloss medium into a well in your palette.

2. Paint the medium over a design on a previously worked and dried page.

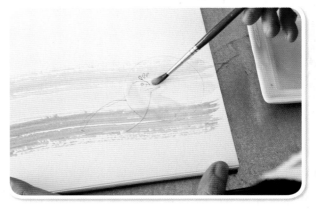

3. I like to vary the amount of medium I use on my page; a thick application will seal watercolor paper better than a thin layer (always experiment first).

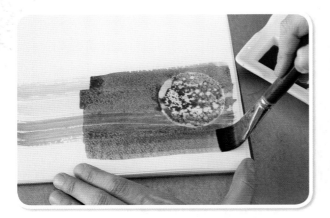

4. Paint over the medium with watercolor or paint.

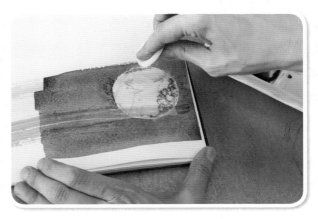

5. Use a rag or soft cloth the remove excess paint from the medium-resisted area.

Transfers: Tracing-Paper Overlay

You can use tracing paper in your journal for many reasons and in many ways. I most often use it to transfer a drawing from one page to another, helping you to maintain the original drawing in a pristine state. When I first began journaling, I was hesitant to work with the same imagery repetitively. Since that time, I have come to the realization that working with the same imagery while using variations in approach, color, collage, stamps, stencils and the like is akin to working in series and has much to teach us as artists. It can also help you to perfect your original drawings, as you can make slight changes with each use.

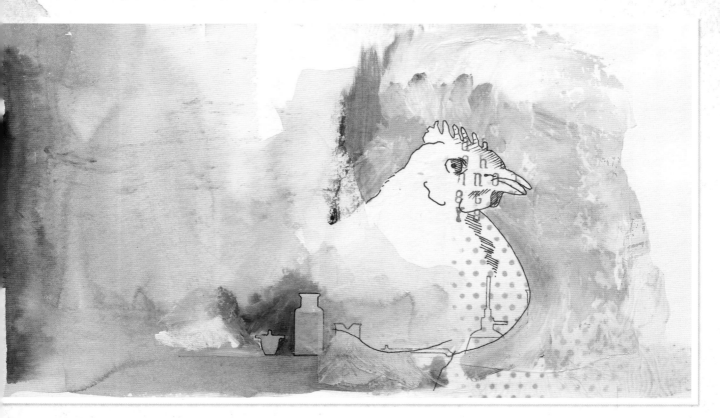

Gather This:

- Tracing paper
- Pencil
- A design worth using more than once
- Gouache or acrylic paint (opaque paints work best with this technique)
- Brushes sized appropriately to your artwork
- Bucket of water to clean your brushes
- Matte medium
- A painted journal page
- Old credit card or a squeegee

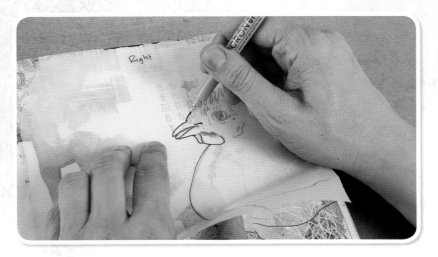

1. Trace a design or image onto tracing paper.

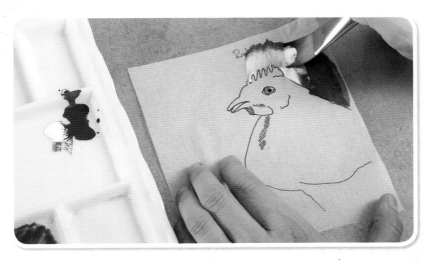

2. Paint the negative space using either acrylic or gouache (opaque paints will work best), and allow the tracing paper to dry.

3. Apply matte medium to a painted journal page.

Everything You Need to Know About Tracing Paper

Tracing paper is an almost perfect tool, allowing you to see if an idea works—or not—without making an immediate and (possibly) detrimental commitment to the page. It also allows you to see if you prefer the transfer in its original orientation or flipped. Because tracing paper is so sheer, you will get great layering results with it. That is, of course, if you are gluing it onto an already painted and textured or otherwise embellished page.

As tracing paper has no sizing and stretches when wet, you will need to either iron the paper flat prior to collaging it into your journal (use the cotton setting) or learn to accept a few wrinkles along with the rich, transparent layering that this paper provides. There is a time and place for both approaches; listen to and honor your intuition.

For best results, paint the negative space of the tracing paper overlay.

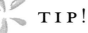

TIP!

Embrace the raw and ripped edges! If you have a felt tipped pen, gently touch the pen to the torn edge, allowing the ink to flow into the raw edge. Watch this occur with abandon and joy; there is magic in watching your art come to fruition.

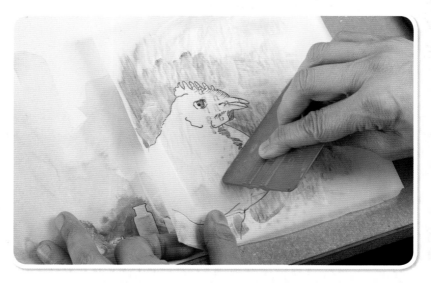

4. Use a credit card or squeegee to flatten the tracing paper transfer to the page; be careful not to tear the tracing paper.

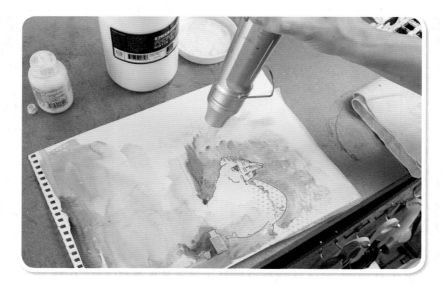

5. Allow the page to dry. You can help it along with a heat gun, if you'd like.

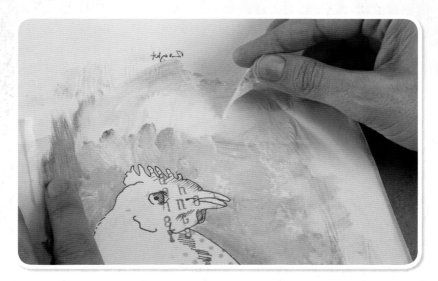

6. Once the page is dry, tear away the excess tracing paper.

A Few Words About Copyright and Ethics

It is my hope as an artist and teacher to instill positive work ethics in my students, to offer them the tools and techniques at my disposal, and then to set them on a course of personal exploration. Each artist must find her own voice and vision. Copying my style or that of any other artist is a great way to teach yourself techniques and a creative approach, but it does nothing to draw the creative voice from your core and bring it to light.

By all means, take classes, broaden your knowledge base and soak in all the information you need to set yourself on your creative path. Foster your ability to see through your teachers' results and into your own use for those same techniques. Your teachers have committed time and energy into presenting work that is true to their own experience, and we do them justice in allowing them their glory.

Your job is to thoroughly integrate what your education and inspiration create and to offer it back to the world in a manner that clearly states that it is yours alone. It is in using techniques and exploring your world that your art will shine through and become as individualized as you are. In fact, this is the point of becoming an artist.

Transfers: Saral Paper

Perhaps you captured a wonderful gesture on an envelope, or you would like to resize and rework a drawing from the past. Saral paper can help you transfer the salient details of your original drawings from one page to another.

Saral paper is a transfer paper that comes in several colors and types, each intended for specific purposes. The graphite version has an even coating of graphite on one side, making that side appear darker than the non-graphite side. It is erasable. The same sheet of Saral paper can be reused until you are unable to transfer good, clear lines.

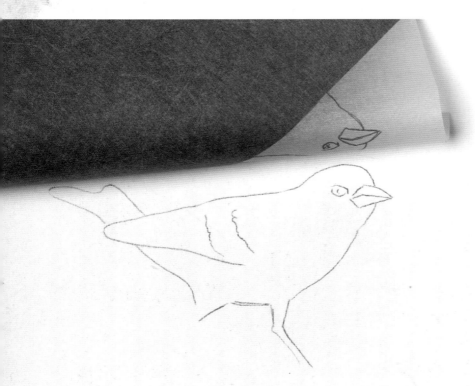

Gather This:

- An original drawing
- Mechanical pencil
- Saral transfer paper (graphite)
- Draftsman's tape

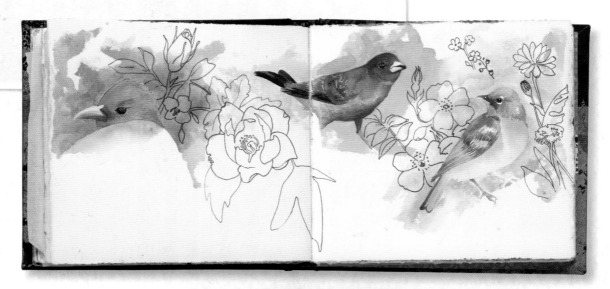

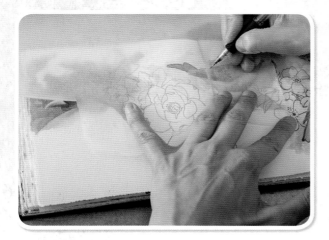

1. Trace your original drawing.

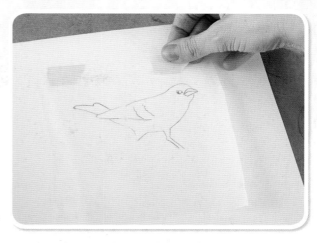

2. Tape the drawing in place on a new page.

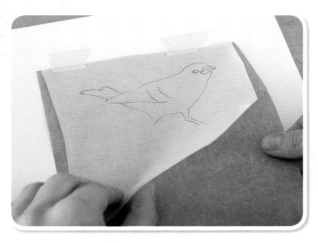

3. Tuck Saral transfer paper graphite-side down beneath your drawing.

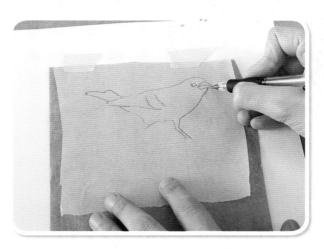

4. Trace over the drawing.

5. Check to see if you have completed all lines.

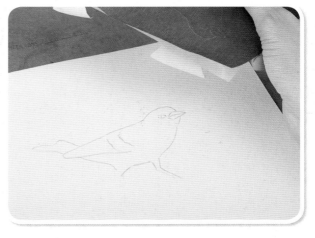

6. Remove the tracing and the Saral paper.

Ruling Pen

Ruling pens are vintage tools that work like pens but that can be filled with thinned paint to draw in colors of your own mixing. Ruling pens have beaks that hold paint. The beak can be adjusted by a thumbscrew to form thick or thin lines. Consistency is the key to successfully filling and using this pen. The paint should be thin enough to draw without dripping out of the beak. If the paint is too thick, it will not flow well and your lines will appear choppy. The best thing about the ruling pen is that it opens a world of possibility when used on cotton broadcloth and silk organza—just think, you can create a rainbow of fine lines and highly detailed drawing on cloth!

If you want to use the ruling pen on silk organza, you will need to place the organza on a scrap of organza to break the surface tension and prevent smudging while your paint is still wet. The ruling pen is a multipurpose tool that can be used easily on most papers and broadcloth without this same precaution.

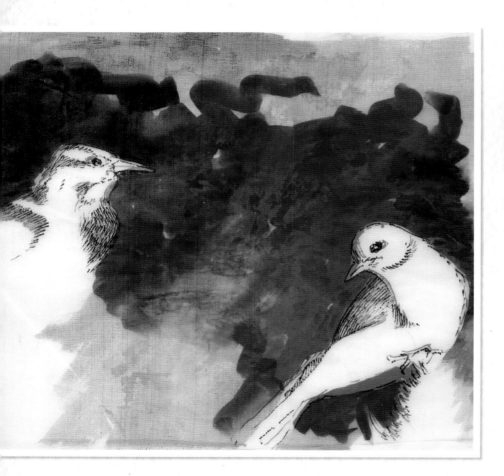

Gather This:

- *Cloth or paper*
- *Paint*
- *Palette*
- *Ruling pen*
- *Dropper bottle*
- *Tape*
- *Scrap cloth (for use with organza)*

TIP!

Don't fret the scrap! It is sometimes prettier than what you just made.

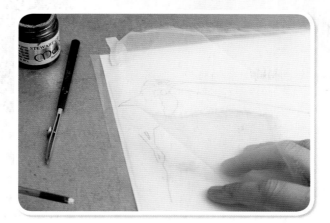

1. Protect your drawing by placing it in a plastic
 sleeve. Then tape scrap organza over your drawing.

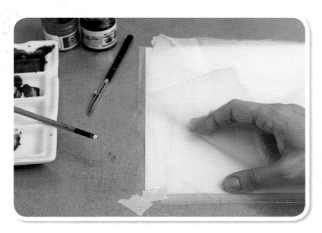

2. Tape your "good" organza over the top of the
 organza-covered drawing.

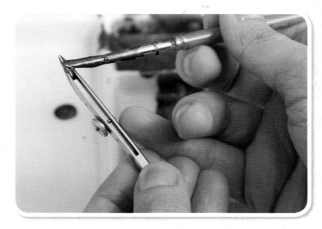

3. Fill your ruling pen by swiping the thinned paint
 off a brush and into the beak of the pen.

4. Draw. A slight angle and a slow and steady hand
 will create longer, cleaner lines.

5. As the name of the pen suggests, you can use it
 to create straight lines by butting a full pen up
 against a metal ruler and using the straight edge of
 the ruler to direct the paint flow.

Collage

We are so lucky to be able to make our own surface-designed papers using resists, stamps and stencils, markers and anything else we have at hand. Found papers, aged and yellowing newspaper, wrapping papers, ticket stubs, scraps of posters and abandoned billboards make terrific inspirational fodder for your journals, too. Always remember that the goal is self-expression.

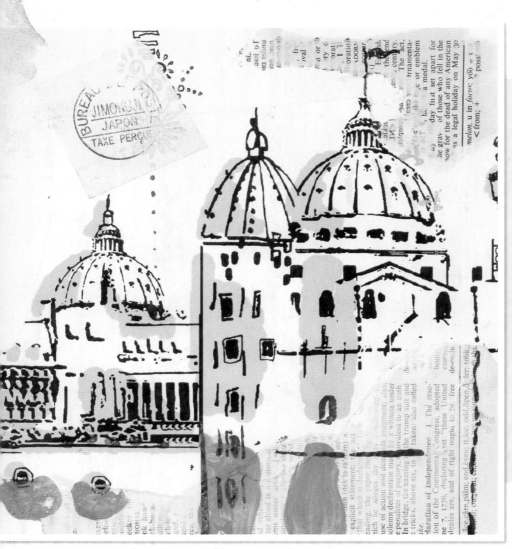

A Few Words About Materials

I use either matte medium or glue sticks to secure paper ephemera to the page. While glue sticks are usually reserved for smaller bits and pieces or to maintain the absorbent properties of watercolor paper by using as little glue as possible, matte medium is used for larger pieces. Using matte medium as a glue on watercolor paper will have the effect of changing the absorbency of the paper. Exploiting these effects is the fun part of being an artist.

THE BUILDINGS IN THIS ARTWORK ARE CUT FROM WRAPPING PAPER. IF YOU COME ACROSS VINTAGE STAMPS AND HAND-CANCELLED MARKINGS, YOU CAN STEAM THEM FREE WITH AN IRON.

My husband loves crossword puzzles, so I sometimes ferret yesterday's puzzle from the recycling bin and use it in my journals. Don't glue the entire page—leave the edges exposed. Then rip excess and unglued portions away.

I love vintage paper, and this acidic brown and aged television label struck a chord with me. When I stumbled on an old television, it was as easy as pulling this label off and tucking it safely into my backpack to get it home.

Sometimes a piece of paper will just float around your studio, make its way to your desk, follow you wherever you go. Glue it down.

Stamps: Handcarved Rubber

Oftentimes, an image or idea leaps from the pages of your journal and asks to be made in repeatable form. Carving your own rubber stamps is a great method to do this. You might choose simple shapes like wonky circles, leaves or stars, or more representational imagery like a flying cat or a bug silhouette. The beauty in carving your own rubber stamps is your ability to attain fine detail, cross-hatching, shading, and intricate shapes.

There are a few tools to acquire prior to proceeding in this adventure. A Speedball Lino set #1 will supply you with a handle and 5 replaceable cutting blades. Each blade will reveal its use and specificity to you as you use them. I tend to use the # 1, #2 and #5 blades most often, and trust me, you will find and use the blades most suited to your own work.

There are also several brands of carving rubber available on the market. Soft-Kut, Moo Cut, Blick EZ Cut and Staedtler Mastercarve blocks work well for most applications discussed in this book. In experimenting with types of rubber to use, consider the end use of your project. Do you want to use your stamps in a journal, on cloth or to make your own papers? If all three are goals, I suggest you seek out the most pliable and thinnest rubber you can find. If you wanted to use the stamp solely on cloth, the heft and bulk of the Mastercarve is likely your best option.

Gather This:

- Design/image of your choice
- Soft-Kut Printing Block
- Tracing paper
- Pencil
- Stamp pads
- Speedball Linoleum Cutter Set #1
- #11 X-Acto blade and handle
- Cutting matte
- Stamp pads

TIP!

The Speedball linoleum cutting blades are clearly numbered on the back of each blade, sequentially. The #1 blade is the smallest and is called a liner, the #2 blade is a V gouge, and the #5 blade is a large gouge. You may find you like using other blades and sizes; these are merely the blades that work well for me. Remember too that these blades are replaceable when dull.

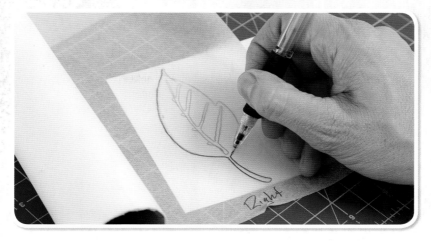

1. Using a soft pencil, trace your design onto tracing paper. I find that 3B lead in a mechanical pencil works well; the lead is soft and the mechanical pencil remains sharp.

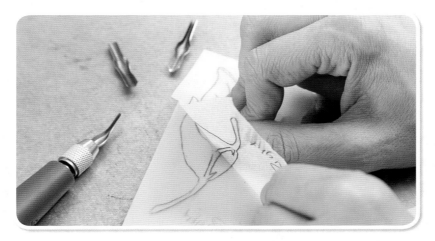

2. Flip the pencil tracing onto Soft-Kut rubber, and finger burnish. Set the drawing aside.

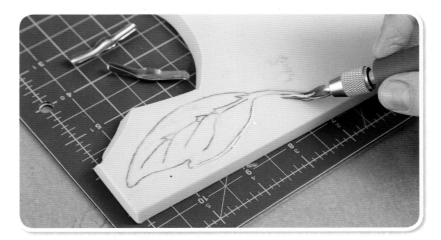

3. Using the #1 blade, start cutting as close to the pencil mark as you can, removing a gentle gouge of rubber just around your drawn line.

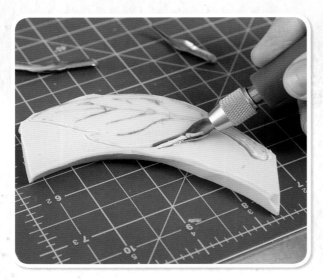

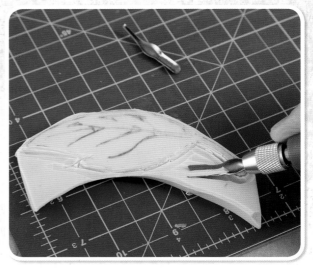

4. Move next to the #2 blade, which will remove even more rubber. Work slow and steady so you do not unintentionally remove an important part of the design. Remove even more of the negative image around your design.

5. Using the #5 blade, remove any divots and lines that might print inadvertently.

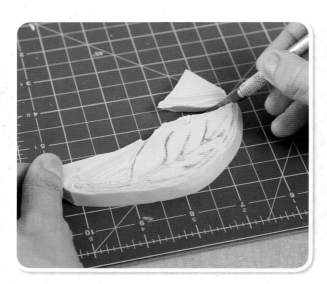

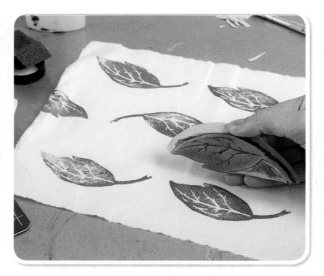

6. Once the majority of the design is carved, cut the remaining rubber away at a softened acute angle, leaving perhaps ⅛" (3mm) or a scant bit more rubber around your entire design. This will provide support while you're using the stamp, but will not print unintended marks.

7. It is a good idea to have a stamp pad nearby and to print a sample. Any high marks will reveal themselves and you will be able to easily cut them away. Rubber stamps can also be used to print on either cloth or paper by daubing an even layer of acrylic paint evenly over the surface of the stamp.

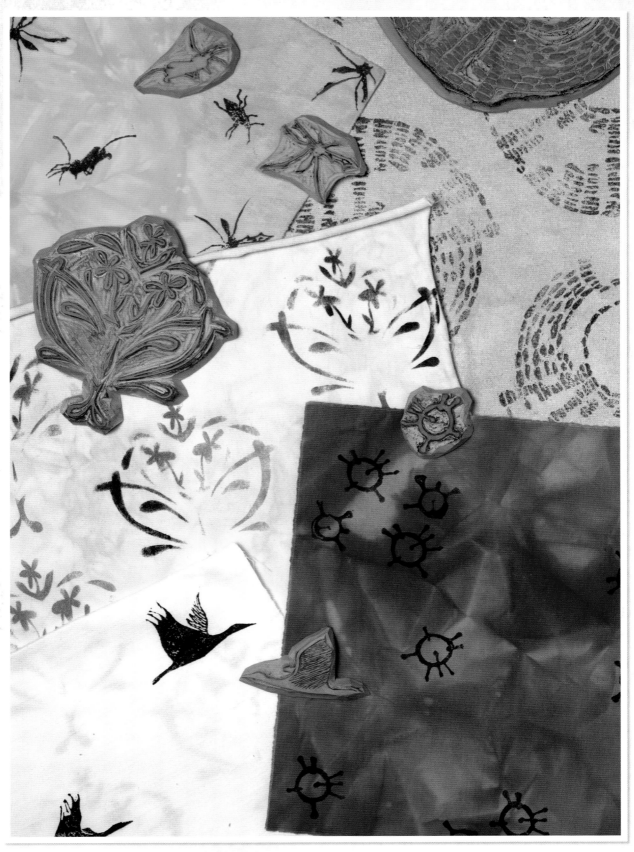

A VARIETY OF FABRICS SURFACE-DESIGNED WITH HANDCARVED RUBBER STAMPS AND PERMANENT FABRIC INKS.

Stamps: Fun Foam

Fun foam or sticky-backed craft foam is an incredibly diverse, if humble, art supply. Fun foam is a distinct stamp-making material because it can be incised, it's easy to cut, it can be used to make single or multicolored stamps and it's easy to store between uses. You can use acetate-mounted stamps right over the gutter of your journal if you want to, and fun-foam stamps can also be used to decorate cloth. Talk about versatile!

Planning is critical to creating multicolored fun foam stamps. Start by drawing or tracing a design directly on tracing paper. Then assess your design and decide how many colors you will use, numbering each area accordingly. One of the eventual stamp pieces will become the anchor or the stamp that ought to be printed first. After the anchor, you will use each subsequent stamp to print each portion of your multicolor fun-foam stamp. The anchor stamp will make itself known to you once you begin printing with the stamps.

You can print your stamps using acrylic paint if you proceed with care. Daub the paint onto the surface of the stamp; do not swipe it on, as this will create pools and drips of paint that will ruin the crisp, clean lines you intend to print. If you see a smudge on the surface of the stamp, rest assured, it will print. Keep a small brush or cotton swab nearby to lift away any smudges and drips.

Gather This:

- Tracing paper
- Pencil
- X-Acto knife
- Cutting mat
- Acetate
- Acrylic paints
- Foam brush
- A piece of cloth/paper to test the design out
- Cotton broadcloth

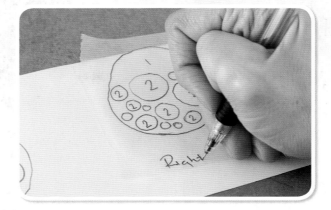

1. Trace your desired design. Then determine the arrangement of colors on the tracing and number each color. Label the right side of your tracing.

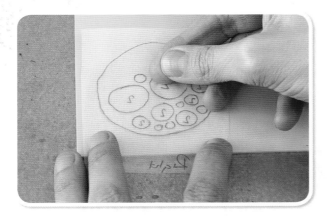

2. Flip the tracing over so the pencil markings are on the surface of the foam, and finger-burnish the design onto the foam.

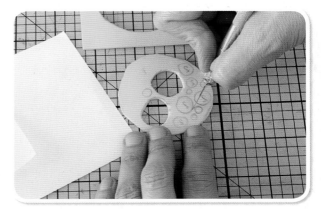

3. Using an X-Acto knife, carefully cut the craft foam.

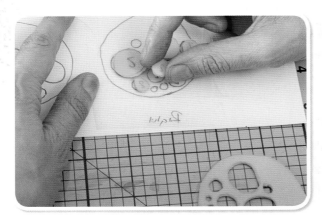

4. Flip your tracing over so the labeled side reads backward. Place a piece of acetate on top of reversed tracing. Peel the sticky backing off the foam pieces, and place the foam pieces onto the acetate according to the tracing.

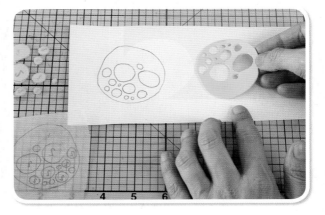

5. Each number or color grouping should be mounted on a separate piece of acetate.

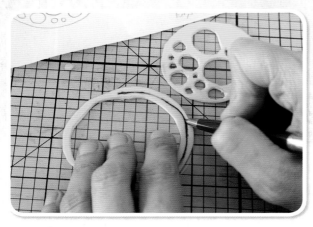

6. Incise some of the foam shapes, if you are so inclined.

 TIP!

Objects that incise fun foam include: a seamstress' marking wheel, pie crust cutter, ball point pens, pen cap and artist spatulas.

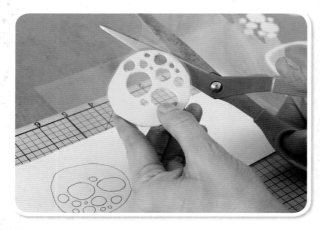

7. Trim the acetate to within ⅛" (3mm) of the foam.

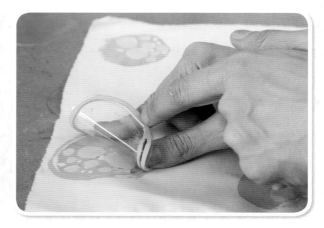

8. Print each portion of your fun-foam stamp with a different-colored paint on a sample of cloth just to make sure everything lines up and to identify the "anchor."

9. Because these stamps are mounted on acetate and because the fun foam is so flexible, you can easily lift a portion of the stamp and peek under it to see if it has printed properly.

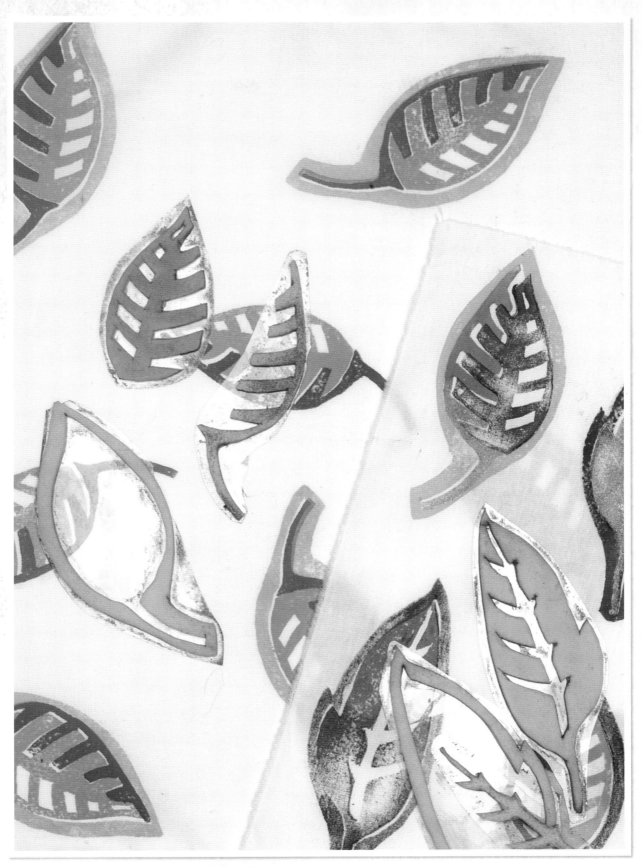

A VARIETY OF FABRICS SURFACE-DESIGNED WITH HANDCARVED RUBBER STAMPS AND PERMANENT FABRIC INKS.

Stencils: Reusable

In order to make a functioning stencil that remains a single sheet of plastic, you will need to understand the concept of the "bridge." Stencils are, for the most part, cutouts of the positive area of a design. If you cut the entire design out, you might have a large area of ill-defined space. Enter the bridge, which enables you to connect the innermost portion of an image to the surrounding background while still maintaining the integrity of the stencil as a whole.

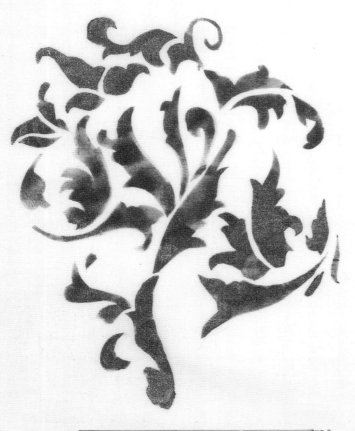

Gather This:

- Template plastic
- #11 X-Acto blade and handle
- Cutting mat
- Well thought-out design
- Acrylic paint
- Dauber
- Palette
- Cloth or paper
- Pen that can write on plastic

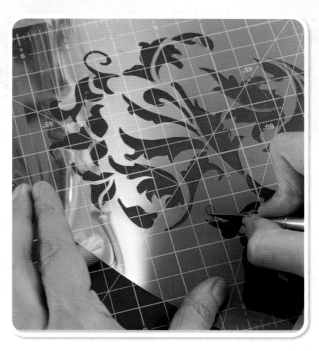

1. Place a drawing or tracing under template plastic. Trace the design onto template plastic.

2. Using an X-Acto knife, cut out your design.

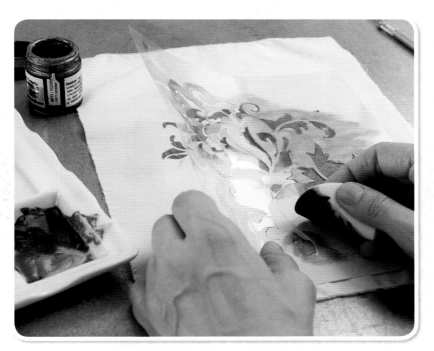

3. Use the stencil to your heart's content!

TIP!

Stencils can be daubed over, spray painted, traced and meticulously painted by hand after tracing through it. So long as you like the results you obtain, you are using the stencil the right way.

Stencils: Frisket Paper and Removable Artist's Tape

Frisket paper goes by several names, masking film and Frisket Film among them. Frisket paper is a low tack, easily removed plastic that can be cut, applied, painted over, and, after a complete drying, removed to reveal the original area of unadulterated paper. Some frisket papers will leave a sticky residue on your paper, which can be removed with a rubber cement eraser. Generally speaking, frisket paper is a more stencil-like approach to masking, but time and patience can give this valuable tool a more painterly look.

Most papers work well with this mask, but not all. Cold-press watercolor papers with a highly textural surface may not allow the frisket paper a firm bond, so some experimentation is called for. Burnishing the frisket in place may help. Bristol board may not be the best choice with this mask either, as I have found that the surface of the paper bonds too well with the tacky side of the frisket paper. It is a good idea to do a trial run if you fear ruining your intended work.

If the paper frisket lifts off the work easily, it can be placed back on its backing and reused a few more times. If the bond with the work is too great, you can use a heat gun to loosen the tack, which will distort and render the mask unusable in future projects.

Removable artist's tapes look like masking tape or Scotch tape. Both remove easily without leaving residue on the page, and can be cut and used as a small detail-sized resist.

Gather This:

- Frisket paper
- Design of your choice
- X-Acto knife
- Burnisher
- Paint

1. Cut a frisket paper slightly larger than your design and peel it away from its backing.

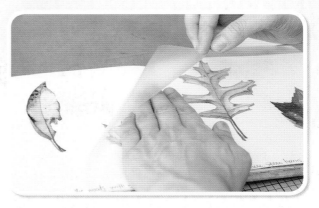

2. Place the frisket paper over the design you wish to replicate.

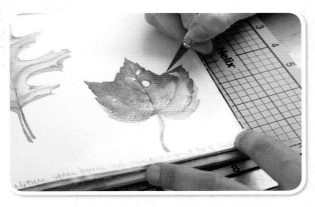

3. Using an X-Acto knife, gently cut into the frisket paper. Lift your cut out away and discard the unneeded portion.

4. Gently but firmly burnish the frisket paper onto the paper. Use a burnisher, bonefolder, spoon or other tool to press out any air bubbles. You especially want to avoid air pockets from forming around the outermost edges. Here I also applied removable artist's tape, which I'll use as a labelling area.

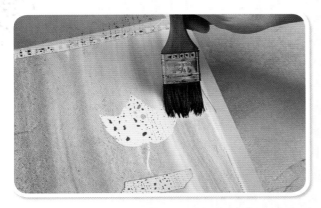

5. Paint over the frisket paper, and allow the paint to dry completely.

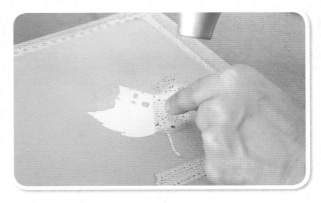

6. If you cannot lift the frisket paper easily, use a heat gun to soften the adhesive. Lift any remaining adhesive with a rubber cement remover, if necessary.

Stencils:
Freezer-Paper Cloth Stencils

Freezer paper is the frisket paper of the cloth world. The shiny side of freezer paper irons to cloth and transforms into a mask, reserving that area of cloth in its original state. As with all other masks, you can use it to reserve the positive or negative space in a design, and then you can paint, daub or lightly spray paint over the mask as you wish. Once the paint is dry, gently peel the freezer paper away to reveal your new design.

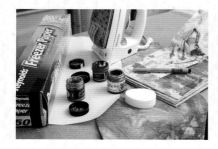

Gather This:

- Freezer paper
- X-Acto knife
- Cutting mat
- Iron
- Paint
- Dauber or sponge
- Pen

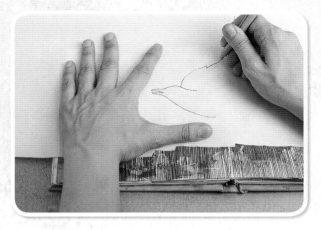

1. Draw onto a piece of freezer paper (shiny-side down) a design you wish to use as a stencil.

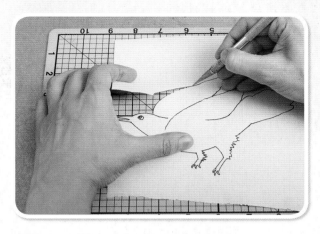

2. Using an X-Acto knife, cut out the design.

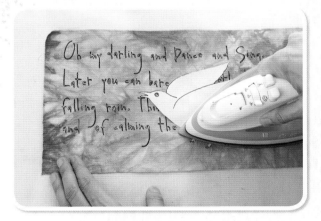

3. Iron the freezer-paper design onto a piece of cloth. Press hard and make sure no bubbles form along the edge of the cut design.

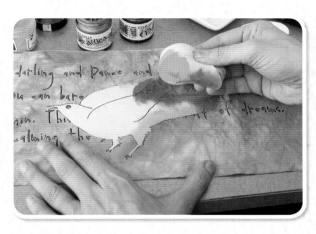

4. Daub, swipe or otherwise paint over your mask. Allow the paint to dry completely.

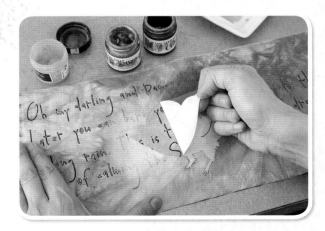

5. Remove your stencil, revealing the masked area.

 TIPS!

• *These stencils will be semi-reusable— they are reusable until the shiny side of the paper no longer adheres to your intended cloth.*

• *You might combine this technique with the ruling pen technique to further delineate the outline of your stencil on the cloth.*

Soy Wax: You Can't Resist This!

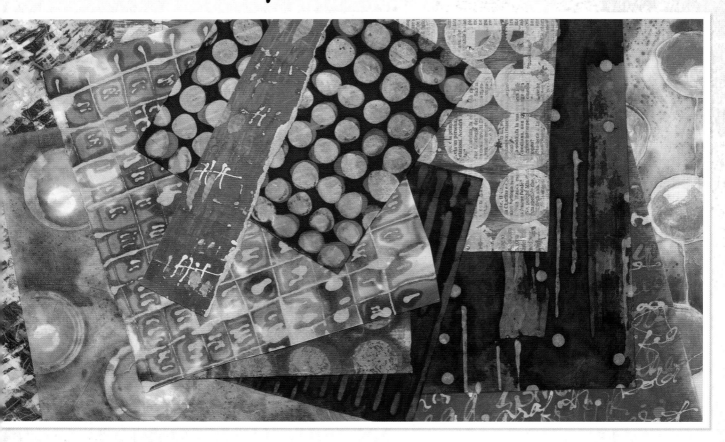

Soy wax is a terrific new resist medium. It's an environmentally safe, food-grade alternative to the paraffin-wax resist techniques of the past. When it's used on paper, there is no need to wash the wax out of the paper; it can simply be ironed out. But I use soy wax as a resist on both paper and cloth, and maybe the most wonderful thing about this resist medium is that it can be washed clean from cloth, simply and easily, in your home washer or under the faucet. No harm is done to your pipes, as this wax is fully biodegradable!

Ten pounds of soy wax is a great amount of wax to purchase and use. Purchase votive or pillar blend wax, which is sometimes called Eco Soya, this wax has a slightly higher melt temperature (180 degrees to 200 degrees Fahrenheit) and is perfect for our purpose. Make sure that the wax you are purchasing does not have any added oils (the added oils help candlemakers scent their wares-but this oil is not easy to wash out of cloth or paper). Purchasing your wax from a textile art supplier or quality craft store with knowledgeable staff is key.

SOY WAX

CHOOSING A WAX POT AND TOOLS TO TRANSFER THE WAX TO YOUR CHOSEN MEDIA

There are a few tools you will need in order to use soy wax as a resist, and a deep-frying pot or pan is foremost on the list. I prefer a deep frying pot to a pan because of the depth of the pot itself and the ability to prop tools up against it while they await use. Most of the tools I use to transfer wax from the pot to the paper or cloth have dimension and depth. It is important that the tool be submerged in the wax and heated to the same temperature as the wax. Once you melt the wax within the pot, it will become dedicated to the task, and you can just allow the wax to harden and await your next playdate.

Purchase your wax pot new so there are no questions as to its potential faults. Look for the easy-release magnetic electrical cord; if you trip over the cord, the magnetic release is a great safety mechanism.

The tools for transferring wax are as varied as their ability to withstand 200 degrees Fahrenheit of heat for any given period of time. I have used: potato mashers, plastic bobbins, shipping foam, bristle brushes, foam brushes, cookie molds and cutters, raffia-wrapped floral wire and the more traditional tjanting tools and tjaps. These tools, too, will become dedicated to the task of transferring wax to your papers and cloth.

Keep your eye peeled when foraging through thrift and antique stores. I have found odd tjap-like stamps that are made of copper and mounted in bases of wood; question what you find and redeploy the odd and overlooked objects whenever possible. EBay is also a terrific resource. Use key words like "primitive kitchen tools." Get creative—you definitely want your mark-making tools to reflect your unique voice.

An improper application of soy wax will appear opaque and sit high atop a single side of the paper or cloth, allowing paint to seep into the improperly resisted area and negating the true meaning of a resist medium.

A proper application of soy wax will appear transparent on both sides of the paper or cloth, creating the proper seal and capturing your paint applications with each subsequent application of paint and wax.

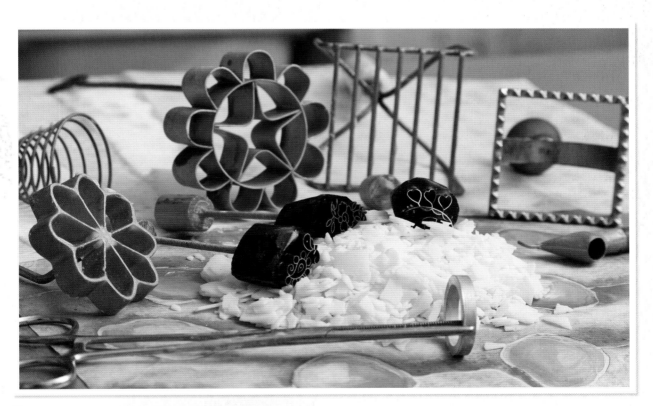

Here are some of the tools recommended for soy wax resist.

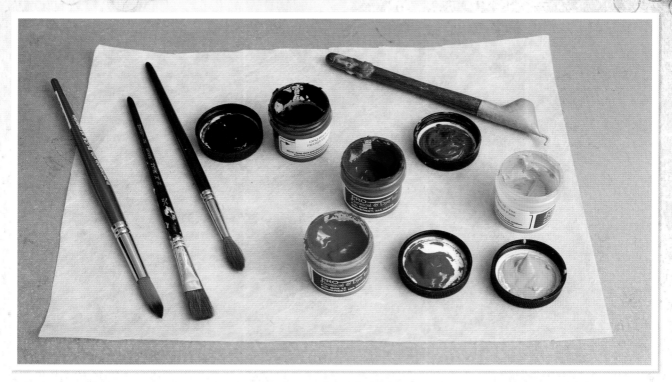

An array of acrylic paints both transparent and opaque will assist you in pairing the best paints to your chosen paper or fabrics. Brushes will help you color paper and cloth, while tjanting tools will allow you to draw with hot wax.

PAIRING PAINTS TO PAPER AND CLOTH

When making surface-designed paper for collage and journaling, machine-made kozo papers are lightweight, strong and fairly transparent. Kozo papers are made from mulberry fiber. There are a few types of kozo paper that I particularly like. Kinwashi, for example, has 1" inclusions in it that are stunning when painted or colored. I suggest you purchase lighter weight kozo paper, which is indicated by weight in grams. These papers have the tendency to be sheer, allowing for previous layers on the page to shine through.

After evaluating the attributes of the kozo and kinwashi papers, the light and ethereal nature of the paint asks to be treated gently with a transparent acrylic paint like Pebeo Setacolor, which allows for a softer hand and acts like a dye without the need to wash or agitate the fibers of the paper. Comparatively, opaque acrylic paint might mask the beauty of this paper, and so it is better suited for sturdier papers like newspaper and tracing paper.

When I work on newsprint and tracing paper, I find that opaque paints work just fine. I love using newsprint for its ubiquitous nature and the way the printed word can show through. The resulting papers are just plain interesting. Newspaper is readily available, and although it is not archival, it is a gorgeous paper to use with wax resist. It should not be overlooked.

When using soy-wax resist on cloth, you will use the same criteria described above when choosing paints. Hand, or the feel of the cloth, is a consideration. Some acrylic paints leave a heavy, plasticky feel that is not conducive to the drape and beauty of cloth. Textile paints are specifically formulated to lend a soft hand to cloth. There are many textile paints on the market to choose from. Read labels, and buy smaller bottles in the beginning, so that you can experiment freely and find the best product for your needs.

Remain cognizant as you build your arsenal of paints, read the labeling, acquire both transparent and opaque paints, and test them out once you bring them home. Paste these samples with copious notes into a notebook; this will be your "external hard drive," and you can refer to it to refresh your knowledge.

FOOD FOR CREATIVE THOUGHT

Non-archival papers have a place in the artist's arsenal because they are readily available, inexpensively obtained, and the yellowing over time is beautiful. But let's ponder why we feel the need for archival papers anyway. What place in our world does all this acid-free paper have? Give the earth a break and try out some non-archival papers. Hundred-year-old paper often shows foxing (bits of rusty metal, chipped off the vat and embedded in the fibers of the paper)—I love to work with such gorgeous papers!

Tools for Working with Wax

A tjanting (pronounced like *chanting*) tool is a pen-like device that acts as a funnel to scoop wax up and deliver it through a numbered tube or tip (the numbers tell you the size of the tip). Thus, you can draw with wax. Take the time to learn the quirks of your tjanting tool. For example, my #2 tjanting tool holds wax that remains hot for extended periods of time, but it requires that I frequently wipe the excess wax off the outside of the barrel. Otherwise, I will get a blob of unwanted, unintended wax.

A tjap (pronounced like *chop*) is an intricately soldered or carved copper stamping block that can be used to print on larger sections of cloth and paper. These tools take some getting used to, as they can really transfer a lot of wax. Practice flicking excess wax off these blocks and you will attain good results.

Cookie molds, ravioli cutters and potato mashers are just some of the kitchen tools that can be heated in the wax pot and used. If you have an item without a handle, a hemostatic clamp is a quick and easy tool with which to submerge an item in the pot.

Soy-Wax Resist

Work with multiple pieces of paper or cloth, cycling through them as the paint applications dry. I often work eight to fifteen pieces of soy-wax batik in a single studio session.

For new artists, whose skills in mixing paint are in their beginning stages, I suggest you work in an analogous color grouping, as if you were to choose a three-color pie from the color wheel (red, orange and yellow for instance; the three colors must touch one another in the color wheel in order to be considered analogous).

Gather This:

- *Presto 6006 Deep Frying Pot (or other wax pot)*
- *Soy wax*
- *Various utensils and tools*
- *Paper: kozo, newsprint, tracing paper*
- *Cloth: cotton broadcloth, silk velvet, silk noil and silk organza*
- *Paint: M. Graham Acrylic, Stewart Gill, Pebeo Setasilk*
- *Foam and cheap bristle brushes*
- *Bucket of clean water*

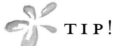

TIP!

It is essential that your tools be as hot as the wax itself. For example, a cast-iron cookie mold will take longer to heat up than a plastic bobbin. Experiment to see how long an object takes to heat to the appropriate temperature.

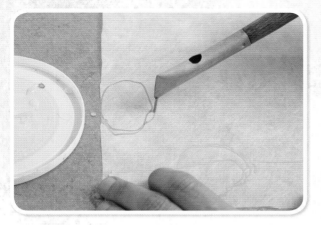

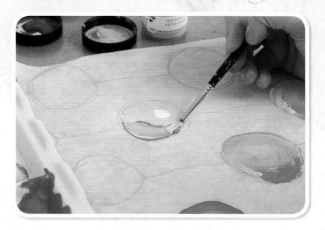

1. Heat your tools to the same temperature as the wax (between 180 and 200 degrees Fahrenheit). Apply the wax to the paper or cloth.

2. Apply the lightest color of acrylic paint to the paper and allow it to dry completely.

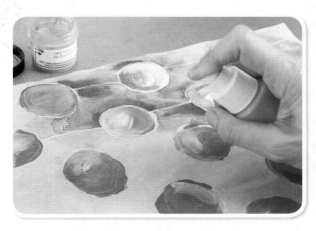

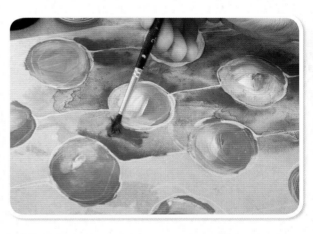

3. Try applying acrylic paints with a watercolor-like flare. Spray or wet the paper or cloth in order to do so.

4. Move the paint into the watery area, thinning it out and moving it around.

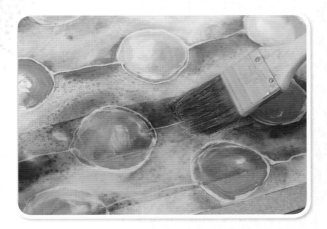

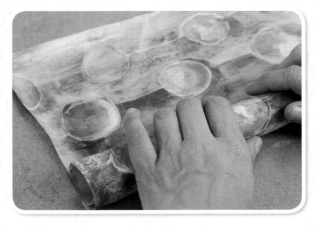

5. For a crackle effect, paint the entire piece with wax.

6. Loosely roll it up and place it in your freezer for 5 to 10 minutes.

Proper Versus Incorrect Application of Soy Wax

A proper application of wax on both paper and cloth (left) will pass through all layers of the fiber and appear transparent on both sides when lifted to light. An incorrect application of wax (right), will sit opaquely on top of the fiber and not pass through to both sides of the paper or cloth.

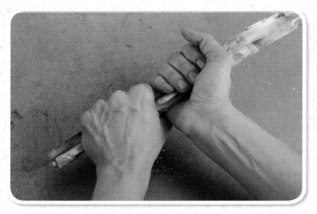

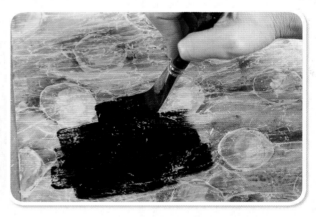

7. Working quickly, remove the waxed piece from the freezer and scrunch the piece over a trash can. Do not allow the work to warm to room temperature.

8. Flatten the work and paint it with a darkly contrasting acrylic paint.

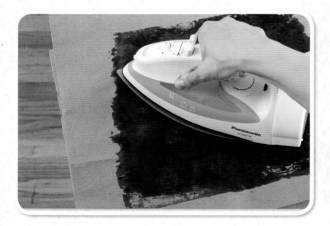

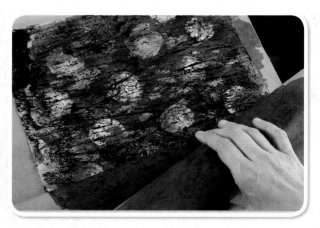

9. Place the fabric or paper between layers of butcher paper and iron the wax away.

10. Paper can simply be ironed and used as is. Cloth will need to be ironed free of the wax and washed to remove the oily feel of the wax. Follow the heat setting instructions on your chosen acrylic fabric paints.

Soy Wax on Cloth (Low-Water Immersion)

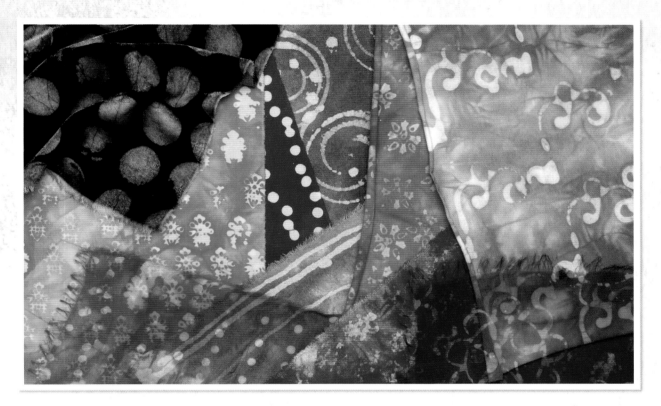

1. Apply soy wax to the cloth.

2. Submerge the cloth in soda ash.

3. Add your dye mixture.

4. Batch.

5. Wearing gloves, handwash the cloth with hot water and detergent. (For more information on washing and detergents, see Chapter 2, Low-Water Immersion Fabric Dyeing.)

Removing the Wax from Paper and Cloth

Removing the soy wax from paper is as easy as wedging the paper between butcher paper and ironing the paper on the setting used to iron cotton. With some papers, you will see a bloom of oil in your design, which must be accepted as part of the design. Washing paper is not advisable.

Removing soy wax from cloth is fairly easy, but it requires a step or two more than paper. First, iron the excess wax between two sheets of newsprint. Then wash your cloth in the washing machine using a hot-water cycle and laundry detergent. Dry it as you would any other cloth. Soy wax is completely biodegradable, and it will not harm your plumbing or the environment.

If you would rather handwash your cloth, simply submerge it under the hot tap, wetting it thoroughly, then soap it up and agitate it until you no longer feel the oily residue. Your hands will be moisturized and your cloth can hang to dry. Because cloth can be washed, no blooms of oil will remain.

4
Drawing

Drawing, sketching and picking up a pencil with the intention of making marks and embodying what you see on paper—these things are often so frightening that people stop well before their best efforts see the light of day. Conversely, and if you have children, you know that young people draw with abandon, they take in their world through their eyes and process it through crayons, paint or whatever else is at hand. So I challenge you: Draw with the abandon of a child. Draw everything you see. Embrace your inner child and hug the intuitive, primitive nature of your first efforts.

There are many approaches to learning to draw. Some suggest committing to working in pen. This will help build confidence and will allow you to find solutions to missteps. If you don't like what you have drawn, turn the page and move on. Others, like me, work and perfect drawings in pencil, only to return later with pen, ink or paint. This usually allows me time to think through what I would like to say on the page—it's a process that works for me. Still others want to illustrate daily findings in the manner of reportage. They seek to draw in a quick, demonstrative manner, combining visual art with notes and stories in the margins of the page.

The point is that there are no absolutes. You must build a practice that works for you, your personality and your creative ambition. This is your journal, and the goal is to use it to the best of your ability, not to do what works for me or the guy down the street.

Make no mistake, drawing takes practice and commitment. I cannot tell you how often I have heard the hollow statement, "Well, *you* know how to draw!" as if this talent were handed down from above with no effort on my part. With almost two decades of practice, I can say that there are gestural lines that are practiced and applied to new situations. These gestures are found by each individual only through practice, like when you absorb the curve of a leaf and how it leans toward you while its tip curls behind itself. These gestures could as easily be called body memory, and we create body memory only through experience.

The elegant and most beneficial aspect of learning how to draw is that the line becomes a form of meditation. Your mind, eye and hand all seek to understand what you see and to convey your vision. With time and practice, your skills will make themselves evident to you and your ability to express yourself as an artist will become expansive.

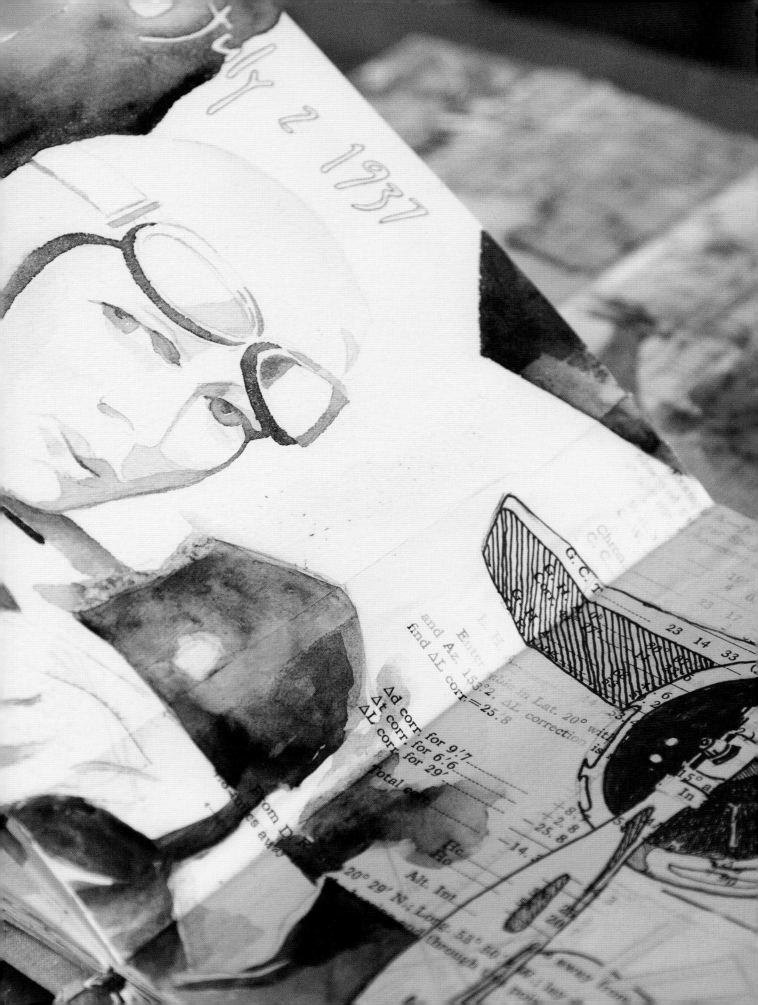

Loosen Up!

The best drawings are loose, flowing, communicative affairs. They speak of the ease and engagement the artist has with her subject matter. Start all of your drawing sessions by shaking out your hands, shoulders and neck. Once your body is loose, choose from a broad array of materials—fat markers, a pocketbrush, a pencil, a graphite stick or whatever else feels right. Take out some scrap paper and draw the contour of an object, blind contour (do not look at the page), use marks to gauge where your lines will form, scribble-draw. Do not spend much time on these drawings; you are merely loosening up and letting go.

Contour drawing:
Draw just the outer edge of your chosen object.

Blind contour:
Do not look at the page as you draw.

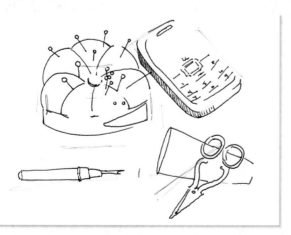

Plot your course:
Use a pencil to help you place where each object will reside on the page. Then draw with a pen.

Scribble-draw:
Go ahead and be loose and sloppy.

Drawing Warm-Ups

In this exercise, you will need to set up a still life. Gather six different pens, pencils and/or paints, a timer and your focus. Set the timer for one minute, and, using one pen per timed minute, draw as much detail as you possibly can. In the examples below I have used a Pentel Stylo pen, Pentel Pocketbrush, Super Sharpie, #2 pencil with a smudge stick, dip pen and ink and #2 pencil. After your minute is up, switch to a different pen or pencil or paint, and repeat the exercise until you have used all six of your chosen implements.

Pentel Stylo pen

Pentel Pocketbrush

Pencil

Super Sharpie

Dip pen and ink

#2 pencil with a smudge stick

Shaded-Moon Exercise

Shading is what gives your drawings form and depth. Shading can run the gamut from a smooth gradation from dark to light to crosshatching (lines that intersect at 180 degrees) to pointillist dots to any other mark you can think up. The easiest way to start is to gradate a line of pencil from light to dark, then move on to drawing lines that are really close together, dots that cluster near one another and then fade away to nothing.

Challenge yourself to use line as shading, fill space, change the type of line you use, break up your lines, use crosshatching; move from dark to light.

Use pointillism to shade the negative space.

Use pointillism to shade the positive space.

Play with density of lines in addition to leaving an area free of lines.

Allow tiny breaks in lines. See how they appear as dots?

Try creating straight lines that bump up against one another but do not intersect.

Define space by crosshatching.

Scribble, sometimes darkly, sometimes lightly.

Try stylizing crosshatch lines.

Additional Drawing Exercises

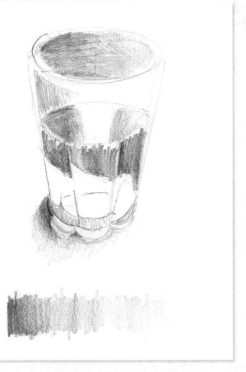

Use a pencil to draw a glass of water.
Drawing a glass of water is a lot of fun and highly educational. There are a plethora of light, medium and dark shades in water. Be loose and easy in your approach with it, and evaluate what you see. Experience the lightest areas compared to the darkest. Try holding the pencil at the eraser end—this will really loosen you up—and also try shading with the tip of the graphite as well as laying the tip on its side.

Use a pen to draw that same glass of water.
Working with pen is totally different from working with pencil. Try shading by densely packing lines side by side, and then spacing them further and further apart. Don't stop there—experiment to see what types of line and shading you can achieve. I have seen artists who use a ballpoint pen as if it were a pencil. Challenge your own limits—you might just surprise yourself.

In 30 seconds or less:
- Do not look at the page; draw the first person you see.
- Draw yourself looking in a mirror.
- Using your non-dominant hand, draw your cat or dog.
- Without lifting the pen off the page, draw everything you see on your desk.

In 2 minutes or less:
- Draw the outlines of everything around the nearest object to you.
- Draw the sky where it meets the trees or buildings.
- Draw a chair.
- Put a pen in each hand and mirror the movements of your dominant hand while drawing a loved one.

Bouquet-Drawing Exercises

Now that you are warmed up, tackle a beautiful bouquet. Look carefully at the bunch of flowers before you. Soak in the details. Evaluate the shapes, both positive and negative. Compare the height of the flowers to the vase they rest in. Is there an object behind or near the flowers that will help in developing the proportions of the bouquet? Answering these questions will help you to build visual relationships.

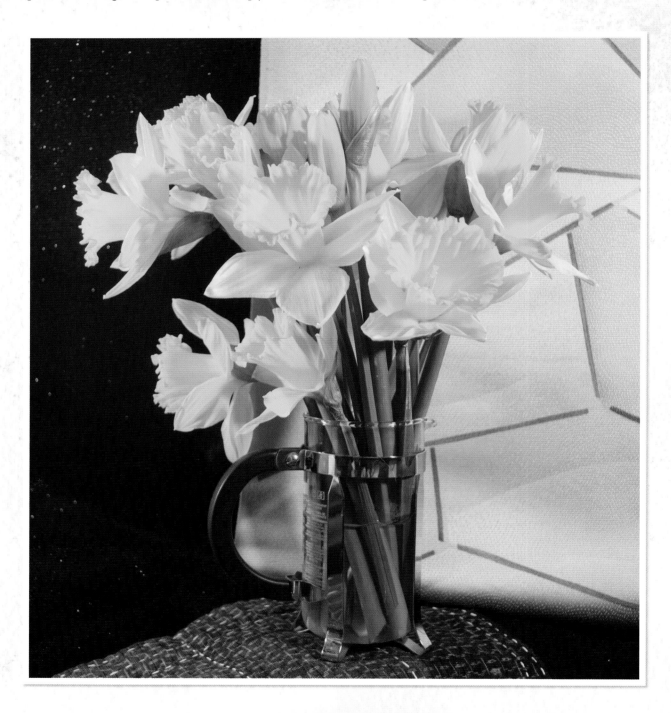

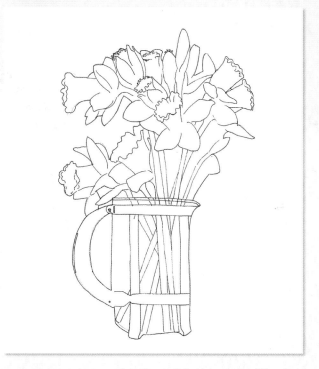

Start out by drawing the contour of the bouquet—remember, just the very outside edges of the bouquet. Use the proportional markers you formulated by asking yourself all those questions. Then, to the best of your ability, fill in the blanks. Some of the shapes won't match up—now is the time to make things up, but don't worry too much about that right now.

Now that you have some experience and have created some visual relationships in your mind, choose a single flower in the bunch and draw it. When you look at the flower you will likely see that the petals have lines that flow in the direction of the petal's tip (points A and B). Drawing these lines helps give body and depth to the object. You will also want to include some interesting details seen on the flower, such as a nip on the edge of a petal or the magnified portion where the stem is refracted in the glass vase (points C and D).

Decorative Drawing

Think of decorative drawing as doodling, playing with line, repetition, pattern and just plain filling space. This is the easiest form of drawing and is a great springboard for more expressive forms of mark-making. You need not limit your explorations to pen or pencil; doodle with a brush and paint, or find a stick, dip it in ink and experience the resultant lines, blobs and marks. Add dots, squares and hash marks. Use stencils, draft shapes in pencil and fill in the shapes with paisley, stripes, drips, X's and O's. There are no limitations in style, material or approach here. After all, we are talking about decoration.

Whimsy and Imaginative Drawing

Sometimes it serves the soul to engage in humorous, playful and inventive drawing styles. Morph that fish into a bird. Draw big-eared bears out for a stroll, a paper doll with a tutu, shoes, coats, trousers and a fresh frock. It is fun to develop characters that express emotions and tell stories.

Start each session with a warm-up, loosen up your wrists, fingers and calm you eye-mind connection. You have permission to use scrap paper, erase to your heart's content and try different media, pens, markers or even paint if that helps you get in the right space.

Nature Drawing

Learning to draw is about forming relationships between an object and the space it occupies. It is also about drawing what you see, not what you think you see. This implies that you are experiencing the plant (or person or object) for the very first time. Even the lowliest of weeds can be an adventure of marks, lines and proportion when experienced with a beginner's perspective.

Take a simple leaf, for example. You can alter the proportions of a leaf, you can show both the front and the back of the same leaf, and you can even diminish a leaf into a withered crunch. Visually isolate each leaf, compare it to its stem, other leaves or other objects surrounding it, and draw the shape you see. Editing extraneous detail is perfectly acceptable, as is highlighting only what is essential as you work toward creating a pleasing composition.

Spearmint, Fig Tree, Sea Lavender
I LIKE TO CREATE THEMED PAGES—PAGES WHERE I ONLY DRAW PLANTS OR ITEMS FOUND ON RESTAURANT TABLES. THESE PAGES ARE COMPLETED OVER TIME.

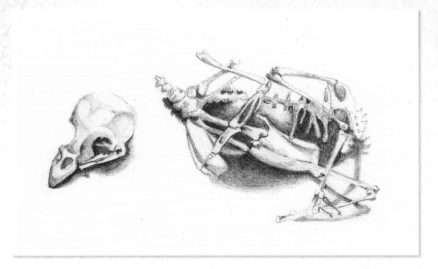

200 Henry Street

I WAS AT WORK AT 200 HENRY STREET WHEN AFTER YEARS OF WANTING A BIRD SKELETON, I CAME ACROSS ONE. THE LITTLE THING FITS IN A RING BOX AND I PERIODICALLY TAKE IT OUT AND DRAW IT.

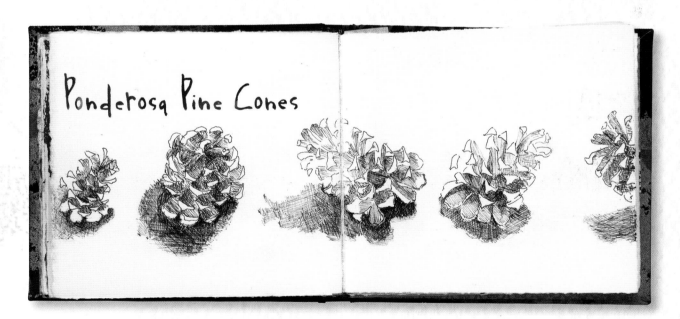

Ponderosa Pine Cones

DRAWING AMORPHOUS OBJECTS CAN BE DAUNTING. KNOW THAT YOU ARE IN CONTROL. YOU MAY EDIT OUT DETAILS OR HIGHLIGHT THOSE DETAILS THAT REALLY EMBODY THE IMAGE. WHEN YOU DRAW AN OBJECT, PUT YOURSELF INTO IT IN THE WAY THAT WORKS BEST FOR YOU.

Drawing the Human Form

Sketching the human body is the biggest challenge an artist can take on. Missteps glare because, whether we realize it or not, we are experts of the human form. Fortunately, there are measurements and markers we can rely upon. These are not steadfast, but they are good rules of thumb.

Stand tall, arms relaxed. Use your own body to make a mental list; where does your elbow touch your torso? Note where your middle finger touches your thigh. Look in a mirror and evaluate the width of your eyes; how far apart are they? Where are your eyes compared to your ears? How wide is you neck compared to your head?

When looking at a model, use your thumb to "measure" the model's head. Estimate how many heads high your model stands compared to this measurement.

Use environmental markers to compare the model to her surroundings. For example, your model may be standing near a chair. Where on her body does the topmost rail fall?

Look at the negative space around the figure, between her legs and arms, for example.

When you find yourself standing and waiting in line at the grocery store, evaluate the people standing near to you, and create mental markers concerning how you would draw them. Look at their proportions, and trace their shapes in your mind's eye. Better yet, if you can, find a figure drawing studio in your hometown and commit to going once a week every week for two months!

When drawing faces:

Eyes are usually one eye-width apart.

Eyes fall at about the halfway point of the shape of the head.

Use the width of the eyes to gauge the width of the nose.

The top of the ear falls somewhere between the eyebrow and the top of the eyelid, and the bottom of the ear falls at the lip line.

The outermost corner of the mouth falls within the pupil of the eye.

The top and bottom lips are usually defined by the shadow of where they meet.

If the person you are drawing wears glasses, leave them for last, drawing as much detail, eyelids, pupils, eyebrows as possible. Do not allow glasses to distract you from capturing a person's facial expressions.

Once you learn the gestural lines and appropriate placement of the body in relation to itself, apply yourself to the study of drawing hands and feet. Even the most accomplished artists have a hard time depicting hands and feet.

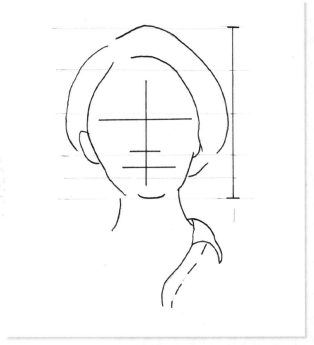

Machine Drawn Line

A sewing machine is more or less a pencil when you are able to drop your feed dogs (the teeth that direct the fabric to move in a straight line under the foot). Yes, you will need to inform yourself about stabilizers, of which there are many in various weights and suited to specific types of cloth. Sulky makes a sampler pack that is good for learning what works best for you.

PAIRING SEWING-MACHINE NEEDLES TO THREAD:

Type of Needle	Fabric	Needle Size	Use
Ball-point	Knit	70/10 100/16	Ball-point needles are blunt and pass through knit fiber easily without damaging the structure of the cloth.
Metallic	For use with metallic and rayon threads	80/12	The eye of this needle is larger and smoother, which allows the thread to pass through the cloth more easily.
Universal	Wovens/knits	60/8 120/19	These needles can be used on wovens or knits. The point is not as blunt as those of ball-point needles and may pierce the fibers of knit cloth. These needles come in the widest variety of sizes.

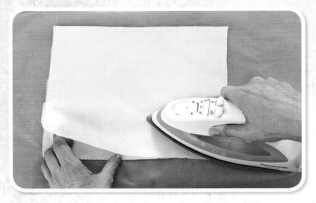

1. Apply an appropriate stabilizer to your chosen fabric.

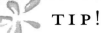
TIP!

If you are interested in transferring a specific drawing to cloth using machine-drawn line, simply trace your drawing onto tracing paper, pin it to your cloth—using a stabilizer if appropriate—and sew through all the layers. The tracing paper will tear away easily. Experiment with both a free approach and a more controlled one.

2. Drop your feed dogs and use a darning or free-motion foot. Place the fabric under the needle of the machine. Begin drawing what you see.

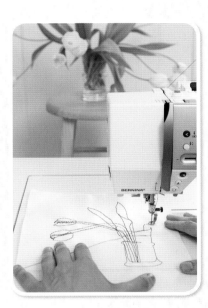

3. It is best to sew-draw the front-most objects first; otherwise, you'll have to decide that drawing over previous lines is OK!

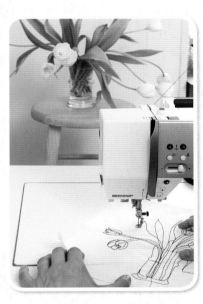

4. Draw what you see. You need not hold the cloth in a death grip. Rather, lightly move it over the surface of your sewing machine. Seek an even flow of line and image.

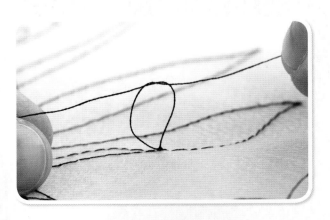

5. If you want a clean, "drawn" look, you will need to stop and tie-off often. Draw loose threads to the back of the work and tie them three times. You might also try a contour line where you draw the object in one continuous line without stopping. Cater your approach to your end goal.

5

The Throw Downs

A Throw Down is a brilliant, passionate expression of talent.
It is also a challenge of the self or others, a showing of ability,
a contribution. In the following chapter, I encourage you to
combine the techniques you have learned and to layer one,
two or three techniques atop one another. You need not stop
at combining three techniques. In fact, I encourage you to
write all of the techniques you have learned over a lifetime on
index cards and randomly choose three, four, five or more to
combine. That is, until they all become second nature and you
begin using the techniques as a means to express yourself!

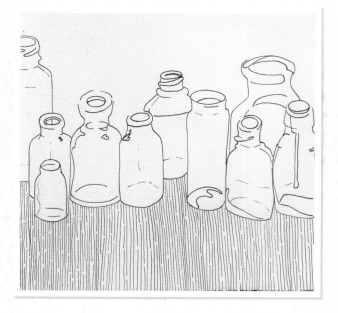

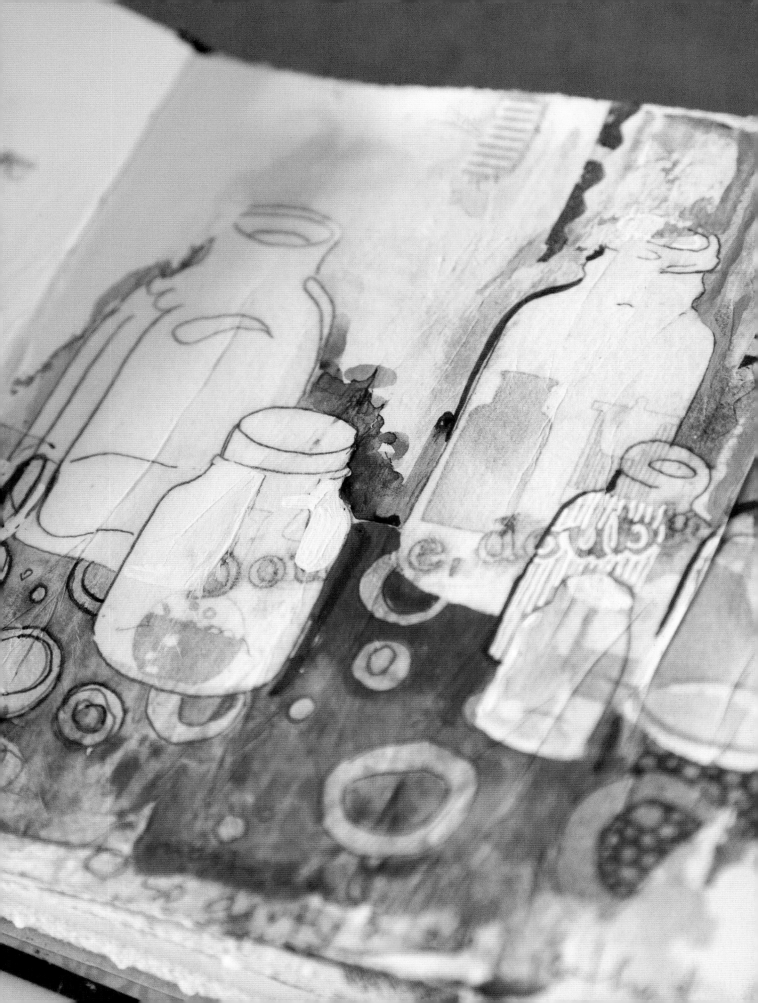

SINGLE TECHNIQUE
CHALLENGES

Single Downs or Single Technique Throw Downs are the simplest of challenges—all you need do is choose one technique and try it out. Experience the possibilities and limitations of the technique, take notes and assess how you might use and improve upon it.

Use Positive and Negative Space

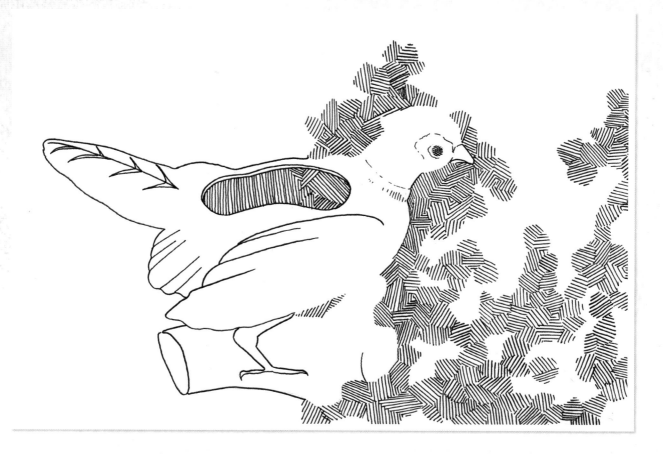

Positive space is the object itself; negative space is the area surrounding the object. In this exercise, draw an object in pencil, then mentally divide the drawing in half. Using your favorite pen, make decorative marks to delineate the negative space on the right side of the object. Then ink in the left side of the object, ensuring that all meaningful details are expressed.

Draw Your Favorite Collection

Happy Horse Bay

In need of a name change

Last spring Cricket and I went to Dead Horse Bay to beach comb. this is the site of an abandoned trash dump, but the stuff you can find is at least 50 or more years old. I collected these bottles that day

There is no better way to improve your drawing skills than to draw similar objects repeatedly. Arrange your collection so that some items are at a side view, tipped over or upside down. The point is to challenge yourself to grow artistically. Training your eye to see and draw perspective is very important.

Draw Within a Grid

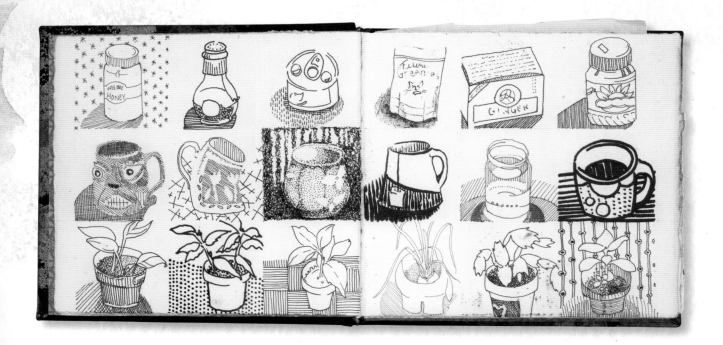

Try drawing like items around the house—cups, plants, spice jars or scissors will work nicely. Using a pencil, draw a grid in a size appropriate to your journal (mine is a 2" [5cm] grid). Play with the idea of maintaining the grid without necessarily filling every bit of each square. Fill in just enough so that you know a grid was used. Use every pen in your collection, one pen per square. Fill each portion of the grid with a new drawing. Use decorative marks to shade, fill space and define each drawing.

DOUBLE TECHNIQUE CHALLENGES

You will use two techniques to create a Double Down. Mix and combine any two techniques from Chapters 3 and 4 on a journal spread. In the early stages of learning to build journal pages, you will have moments of complete awe as you watch a drawing or painting emerge and witness how the textures play with and off one another. You will be well on your way once you complete these challenges.

Stamp and Paint

Believe it or not, you can use watercolor paints to ink your favorite stamps. Keep a squeeze bottle with four parts water to one part liquid soap near your paint palette. Mix a pleasing color in your palette using watercolor paint. Then dispense one drop of soapy water into the paint and distribute it evenly. Use a brush or foam brush appropriately sized for your stamp and apply a thin layer of paint over the stamp's surface before pressing the stamp into the page. Allow the page to dry.

With a sense of abandon, sketch a still life directly over the top your stamped layer using watercolor paints. Once the paints are dry, paint the negative space around your subject. Take care not to wet the painted drawing too much, as watercolor can migrate and change with re-wetting.

Found Object Stamp and Frisket Paper

Almost anything with texture can be used as a stamp. I have seen string-wrapped wood, crumpled paper towels, textual packing foam, chair glides and foam tape all used in the making of stamps.

Try using gouache on your found object stamp. If the surface tension of the paint seems inconsistent, use a drop of soapy water to help the paint adhere to the stamp before printing your journal page. Once the paint is dry, apply a paper frisket cut-out to the page and burnish it firmly in place. Using watercolor, paint over this resist. Be aware that the gouache will lift and mix into the watercolor paint, as both paints are water-soluble.

Stencil and Pen Play

Daub or sponge gouache over a stencil and allow it to dry.

Using your favorite pens, draw on top of this layer, playing with texture while addressing both the positive and negative spaces.

TRIPLE TECHNIQUE CHALLENGES

It is in combining several techniques that your work will begin to mature and acquire sophistication. You can gather any three techniques you like from Chapters 3 and 4 to build and layer beautiful pages. Some techniques work better with a few previous applications, like semigloss medium as a resist or tracing paper overlay with collage or pen play. This is, after all, a means to layer and deepen your journal practice.

Saral Paper Transfer + Liquid Frisket with Gradation + Dry on Dry Watercolor Painting

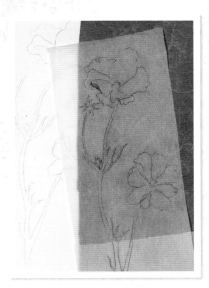

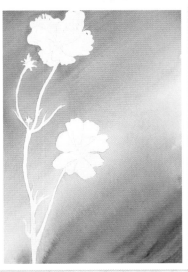

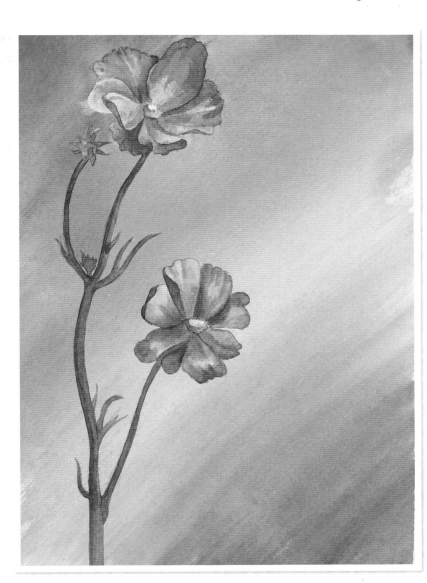

Use Saral paper to transfer a favorite drawing.

Paint the positive portion of the drawing with liquid frisket. Allow the frisket to dry. Mix two colors of watercolor paint, and using a brush appropriately sized to your page, spritz the page. Feather one color downward along half the page. Clean and reload your brush with the second color, and feather it toward the top half of the page until the two colors meld. Once the paint is completely dry, remove the frisket with a rubber cement remover.

Paint the image using a dry-on-dry watercolor approach.

Collage + Tracing Paper Overlay + Decorative Drawing

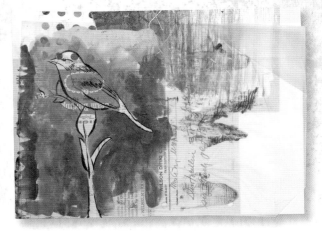

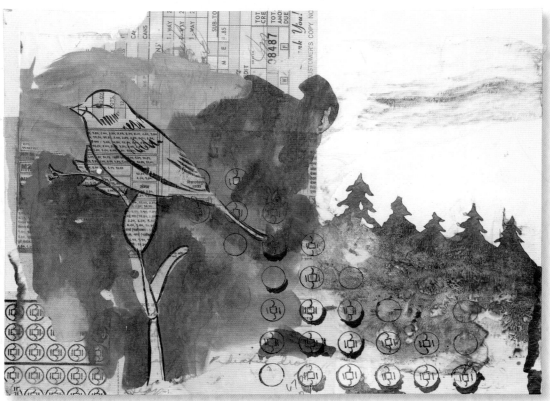

Collage ephemera onto your journal page. Use Tracing Paper Overlay to add a favorite image over the collaged layer. Then draw, paint or stamp atop all layers to integrate the design elements.

Doodle +
Semigloss Medium Resist +
Watercolor and Gouache

Draw, sketch or otherwise add imagery to your page. Use semigloss medium to trap and resist your first layer. Brush a watercolor wash over the dried medium. Once the watercolor wash is dry, paint a decorative pattern over these last two layers, using gouache. The transparency of watercolor compared to the opacity of gouache is an amazing thing to play with and embrace.

Exploded View #1: Rainbow Grackle

I like to create personal challenges where I take an idea not often broached and make it mine. In this case, I chose to create a page in rainbow colors while drawing in a messy style. To create this page, I used matte medium to glue a surface-designed piece of newspaper down (it is yellow with gold dots). Then I stenciled random words from songs on the radio (it takes a long time to create sentences when you are using stencils to write with—which

can be interesting. Verbal thoughts and ideas will pile up without clear sense. Then I drew the boat-tailed grackle right over the gutter of the journal. Once the bird was drawn, I felt the need to give him a horizon to stand upon, so I squeegeed acrylic paint in an off-kilter line. I also painted the upper-right hand corner and the left side of the page, darkening some areas while highlighting and drawing attention to others.

My favorite collection drawing is *Happy Horse Bay* (see Chapter 5, Draw Your Favorite Collection), and I wanted to illustrate how to take such a drawing and transform it into a full-page spread in your journal. Using tracing-paper overlay, I traced the image and painted the negative space with gouache before gluing it atop a new (but already in progress) page.

Painting the reflective surfaces of a glass bottle is not the easiest challenge! To simplify the task, I mixed a limited palette of paints in light blues and dark greens. I drew the bottle and reflected areas in pencil. Note the subtle difference in tone where the watercolor paint overlaps the sealed words "*alaprima? prima*" and also the area where the gouache paint smudged when I glued the tracing paper overlay.

This page speaks to the importance of using a full array of lights mediums and dark hues in your work, so don't be shy!

Techniques and tools used on this page include: stenciling, pen play, tracing-paper overlay with gouache (glued with matte medium), transferred ink from a laser print by ironing, wrote "*alapima skills? prima*" (I often take notes on my pages and later found out that alla prima is a wet-on-wet oil painting technique), penciled text, sealed the text with matte medium, watercolor painted the green glass bottle, highlighted details with a white Uniball Signo pen and a Faber-Castell Pitt F Sepia pencil, and collaged surface-designed paper and a bit of cloth shred from a favorite pillowcase.

Edit

you do not need to draw everything you see. You are allowed to edit, enliven, and have fun.

get distracted

gotta have fun, right?

THEN Draw you ...only you se...

In this is a teaching spread, I took a still-life photograph of daffodils and traced the outline exactly as I saw it, painted the negative space around the flowers with gouache, and used matte medium as a glue to secure the tracing paper to the page. Then I drew the vase, a close-up of a single flower and an apple, using techniques such as mark-making, shading and decorative drawing.

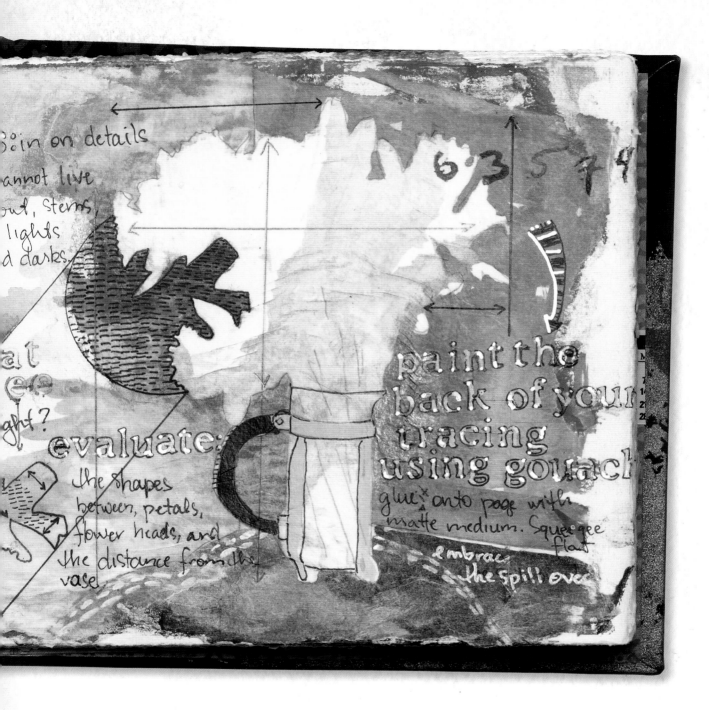

I have always been fascinated by exploded view and magnified technical drawings, and I embraced that idea in trying to explain how to look at and see what you are drawing or painting. I also think it is fun to use odd handmade stamps on your pages. The numbers and the bug just fit into the composition.

Techniques and tools used in this page: tracing-paper overlay, painting with gouache, drawing, stenciling, stamping, painting with watercolor, Uniball Signo pens in gold, silver and white, and pencil and smudge stick.

6
The Gallery

Keeping an artist's journal is the adventure of a lifetime. With years of journaling behind you, you can easily leaf through your journals, page after page, and find inspiration. Images will ask to be made manifest, and with the ease and confidence of techniques fully explored, you will know how to realize your ideas. Without thinking twice, you will know exactly which technique or approach to apply to a given situation.

Maintaining a journal is an investment in your artistic skill set. Learning to draw and mix color will help you see and experience your world more fully. Utilizing these skills will improve your artwork exponentially, so start now; journal everyday for 21 days, and you will be well on your way to forming the journaling habit.

In the next few pages, you will see some of the objects and ideas that my most recent journals have inspired, and this is just the tip of the iceberg.

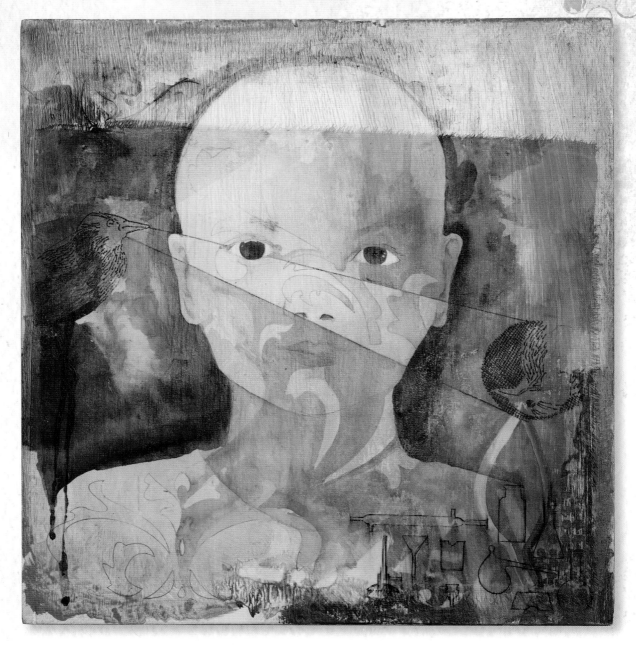

Self-Portrait Post Sixth

Birds play a seminal role in my life, so when I decided to create a self-portrait, I thought it interesting to include an idea from a previous journal page in my representation. *Bird Seeing Self* plays with the idea of seeing yourself, in reverse. I used a ruling pen with acrylic paint to trace and transfer the drawing onto silk organza. I then used matte medium to glue the cloth to the board. I made sure the ray of the *Bird Seeing Self* passed through my own eye, because I thought it fitting.

ACRYLIC PAINT ON PINE BOARD, STENCIL, ORGANZA WITH RULING PEN GLUED USING MATTE MEDIUM, HAND-DRAWN AND PAINTED SELF-PORTRAIT.

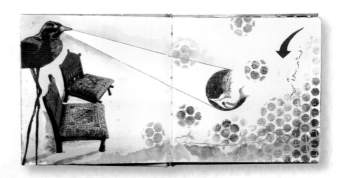

Wings in Cloth

In making a self-portrait stamp, I opened a world of ideas. The stamp itself was simple—a female person with arms of feathers. But as I started thinking about it, I wondered, *Is there a way to make wings or a garment with drape and beauty that might remind me of having wings?* Hence a simple rectangle of wonderfully surface-designed cloth, layered and simply stitched.

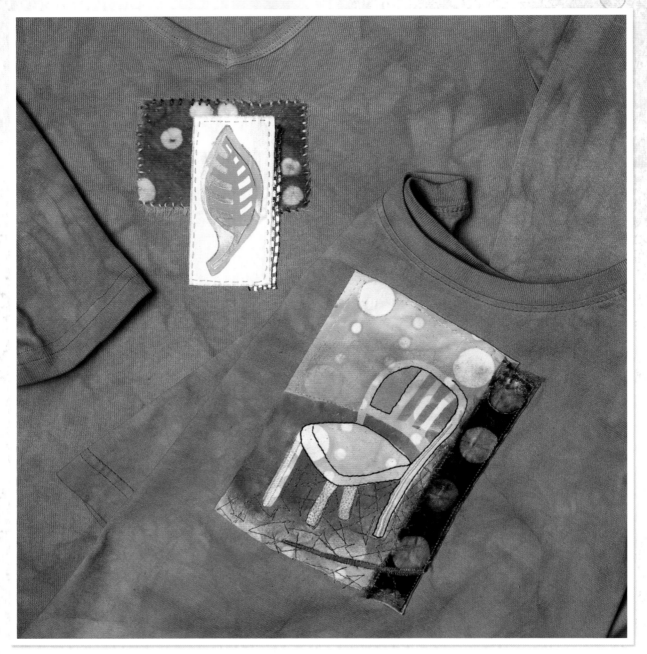

Journal-Inspired Wearable T-shirts

Embellishing your own clothing is a great way to show off your creative efforts. Doodled on a page of my journals, the simple leaf shape leapt from the page to be made into a multicolored stamp. The chair was as easy as daubing over a freezer paper cut-out and using a machine-drawn line to accentuate and the lines and secure the design to the T-shirt. Velvet is a rich accent, while most any ribbon can pull your chosen fabrics together quite nicely.

LEAF T-SHIRT: SOY-WAX-RESISTED LOW-WATER-IMMERSION DYED VELVET, MULTICOLOR FUN FOAM STAMP, RIBBON, HAND-STITCHED WITH EMBROIDERY FLOSS

CHAIR T-SHIRT: SOY-WAX-RESISTED JERSEY AND SILK VELVET LOW-WATER IMMERSION DYED, FREEZER-PAPER-RESISTED WITH PAINT, MACHINE-DRAWN LINE.

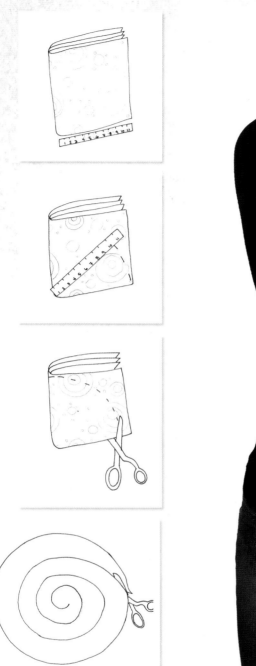

Spiral Scarf

A simple 24" (61cm) square of cloth can be surface designed, dyed and cut to make a lovely froth of a scarf. Because the scarf is cut on the bias, the cloth will not fray. Imagine this scarf in hand-dyed and stamped silk gauze or doubled with a silk velvet scarf in a contrasting color.

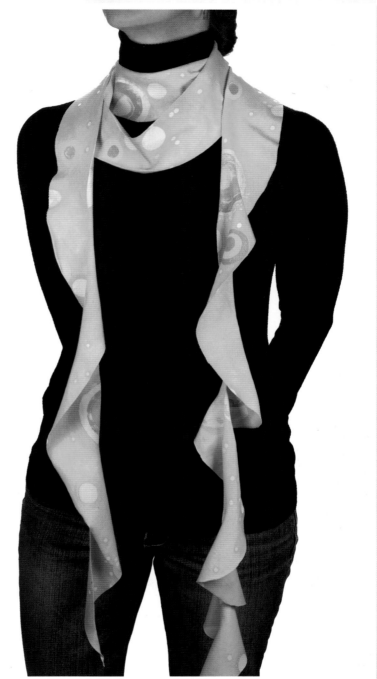

MULTICOLOR STAMP, SOY-WAX RESIST,
LOW-WATER IMMERSION DYED.

Poppy Scroll

This scroll is a gentle and ethereal offering to hang in your office or studio. It is paper glued to paper and hung on a simple dowel with an embroidery-floss hanging thread. And what better way to remember a day spent sitting in front of a gorgeous flower and drawing it than to make a scroll inspired by it?

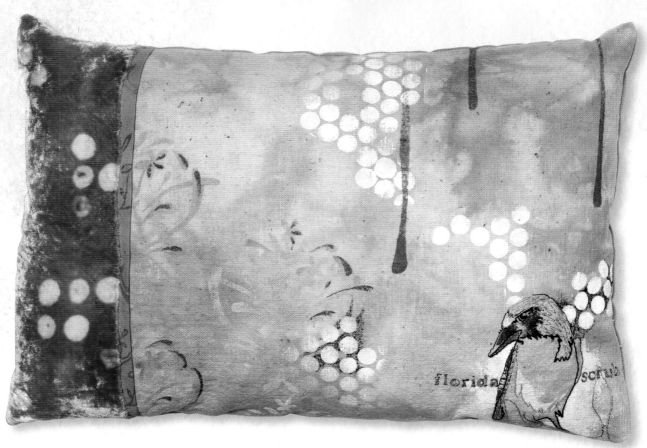

Florida Scrub Jay Pillow

SILK NOIL, SILK VELVET, COTTON BROAD-
CLOTH, LOW-WATER IMMERSION DYE, STAMP,
STENCIL, MACHINE-DRAWN LINE, ACRYLIC
PAINT, AURIFIL MAKO COTTON THREAD,
RAYON EMBROIDERY THREAD

While the velvet was soy-wax resisted and dyed, the narrow trim to its right was dyed and stamped. The majority of this pillow was stenciled and stamped on silk noil. The scrolls were stenciled and highlighted in paint with a ruling pen. The circles were stenciled using sequin waste; the drips were daubed through a quick freezer-paper stencil. The Florida Scrub Jay was transferred to the fabric using tracing paper, which I sewed through and then tore away. Then I painted the negative space around the bird to make him pop, and I painted his eye, beak and portions of his body before making the pillow.

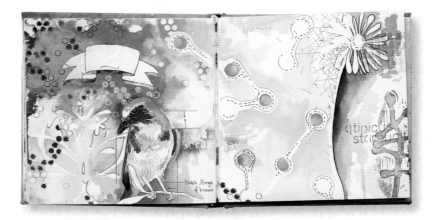

The Beast

I dyed, printed and resisted and stamped about 85% of the cloth used to make this quilt. I call it *The Beast* because it is sized for a king-size bed and was a beast to put under the sewing machine to quilt. Having found a commercial print of cats, I was lucky to find a semblance of Arrow and our beloved Monk on a commercially printed fabric, and so used the images to honor our cats and their importance in our family.

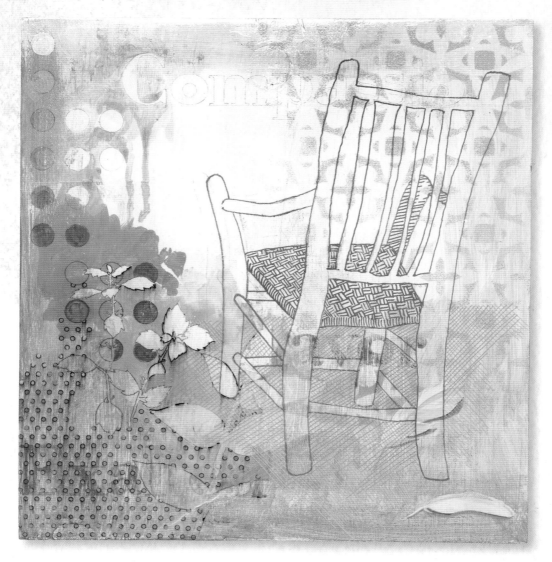

Yellowstone Relaxation

Pine board is a great surface to paint on. I purchase six-foot (2m) lengths and ask for help at the lumber store in cutting them down to 12" (31cm) squares. I prime both the front and back with gesso (to alleviate warping).

To create this piece, I smeared yellow ochre paint onto the outer edges of the board, daubed through a stencil, wrote on the image, painted the feathers with acrylic, transferred the line drawing of the chair onto the board using a Saral paper transfer, and used gray acrylic paint and a ruling pen to draw the chair. A tracing paper overlay was used to place the spearmint in the lower left corner. Finally, I used a commercial stencil to draw small circles in pen, and I applied a dot of pink acrylic paint to each.

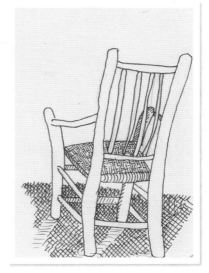

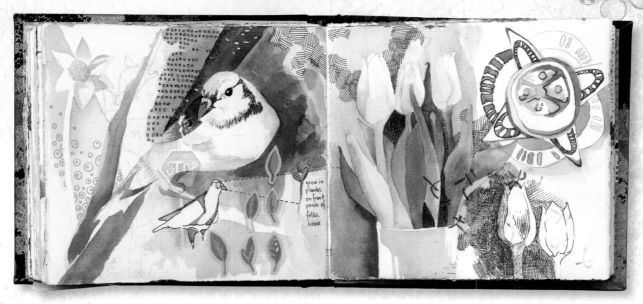

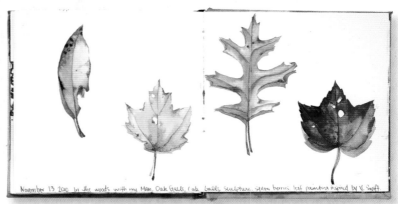

November 13 2010 In the woods with my Man, Oak Galls, rab Galls Sculpture, spine berries leaf painting inspired by V. Swift

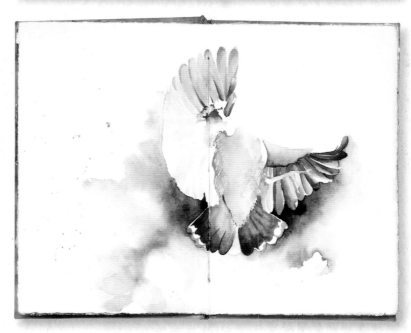

Clockwise from the top:
FLORIDA SCRUB JAY; AUTUMN LEAVES; RED-BREASTED NUTHATCH; DAISIES AT KRIPALU

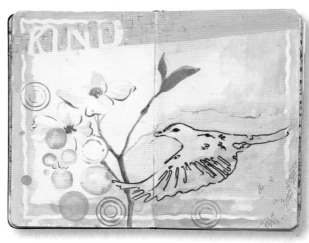

Clockwise from top left:

Mixed Media Mélange; Watercolor Wash with Diluted Bleach, painted with a nylon brush; Kind: a study of Dogwood and Birds; The Journal Study Gals. (It is fabulous to have a group of friends who all love art and journaling. Make your own group and go out to museums and have coffee together.)

Resources

Here is a list of manufacturers and suppliers. Each website stores a great deal of information about specific products. Whenever possible, please shop locally; it keeps a higher percentage our hard earned dollars in the hands of our local mom-and-pop stores and benefits the communities we live in.

MATERIALS

Aurifil
thread
aurifil.com

Candlescience
soy wax (Eco Soya PB)
candlescience.com

Dharma Trading Co.
fabric and dyes
dharmatrading.com

Golden Artist Colors
silkscreen fabric gel, gel mediums
goldenpaints.com

Graffix Plastics
plastic sheeting and mylar
grafixplastics.com

Jacquard Products
textile paints
jacquardproducts.com

M. Graham
watercolor, gouache, acrylic and oil paints
mgraham.com

Moleskine
journals
moleskine.com

New York Central Art Supply
kozo, inwashi and watercolor papers
nycentralart.com

Pro Chemical & Dye
dyes and related products
prochemicalanddye.com

Strathmore
journals, paper
strathmoreartist.com

Sulky
fabric stabilizers
sulky.com

The Crafter's Workshop
commercial stencils
thecraftersworkshop.com

BLOGS AND WEBSITES

Reclinerart's Posterous:
Mixed Media from Teeny Tiny Table Studio
reclinerart.posterous.com

Roz Wound Up
rozwoundup.typepad.com

Live or draw in an urban setting? Check out:
urbansketchers.org

Search for a sketch group near you:
meetup.com

FURTHER READING

Diehn, Gwen. *Real Life Journals: Designing and Using Handmade Books*. Asheville, NC: Lark Crafts, 2010.

Dobie, Jeanne. *Making Color Sing-Practical Lessons in Color and Design*. New York: Watson Guptill, 1986.

Jennings, Simon. *The New Artist's Manual*. San Francisco: Chronicle Books, 2005.

Sonheim, Carla. *Drawing Lab for Mixed Media Artists*. Minneapolis, MN: Quarry Books, 2010.

Steinhart, Peter. *The Undressed Art: Why We Draw*. New York: Vintage Books, 2005.

Index

dedication

For David,

*Whose strong hands
held cupped
my fraying soul
until I returned
whole.*

I love you. Fierce.

about the author

Melanie Testa is an artist and textile designer living in Brooklyn, New York with her husband, David, and her Supercat, Arrow. She is the author of *Inspired to Quilt: Creative Explorations in Art Quilt Imagery* and a DVD titled *Print, Collage, Quilt.*

Melanie keeps a blog through which she hopes to encourage your artistic endeavors via video prompts, challenges, tutorials and fun mixed-media happenings. Visit with Melanie at melanietesta.com.

ACKNOWLEDGMENTS

I signed the contract for this book in the same week that I was told that I had breast cancer. I would like to thank the universe (and everyone at North Light—especially Tonya Davenport and Kristy Conlin!) for giving me a project sufficient to distract me from my bodily needs. To my family, who rallied behind me, called, listened and came to hold my hand—thank you. A heartfelt thanks to Arrow for warming my lap and encouraging me to sleep. I would also like to thank the Journal Study Gals: Benedicte, Teri, Shirley, Pat, Gwen and Pamela whose silly antics and pile of postcards were a balm. Special thanks to Patricia Gaignat for teaching me about multicolored fun foam stamping—an addiction with no 12-step program to support it; Brenda, period; and to those of you who sent gifts, letters, cards, hats and prayers—thank you. You have expanded my world and showered me with love in my time of need.

And to you, dear reader, remove all obstacles and make stuff—lots of stuff. Praise yourself for the smallest of efforts. Go deeper and deeper still—become the artist you know yourself to be.

16 15 14 13 12 5 4 3 2 1

DISTRIBUTED IN CANADA BY FRASER DIRECT
100 Armstrong Avenue
Georgetown, ON, Canada L7G 5S4
Tel: (905) 877-4411

DISTRIBUTED IN THE U.K. AND EUROPE BY F&W MEDIA INTERNATIONAL
BRUNEL HOUSE LTD, NEWTON ABBOT, DEVON, TQ12 4PU, ENGLAND
TEL: (+44) 1626 323200, FAX: (+44) 1626 323319
EMAIL: ENQUIRIES@FWMEDIA.COM

DISTRIBUTED IN AUSTRALIA BY CAPRICORN LINK
P.O. Box 704, S. Windsor NSW, 2756 Australia
Tel: (02) 4577-3555

ISBN-13: 978-1-4403-1434-6

www.fwmedia.com

Edited by *Kristy Conlin*
Designed by *Julie Barnett*
Production coordinated by *Greg Nock*
Photography by *Scott Jones/Scott Jones Photography, and Al Parrish*

metric conversion chart

to convert	to	multiply by
inches	centimeters	2.54
centimeters	inches	0.4
feet	centimeters	30.5
centimeters	feet	0.03
yards	meters	0.9
meters	yards	1.1

Draw, paint, stencil, dye!

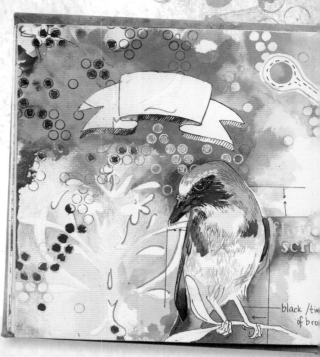

With *Dreaming from the Journal Page*, you'll have tools and inspiration beyond your wildest dreams!

Looking for more? Visit
createmixedmedia.com/dreaming-bonus-materials
for access to exclusive photos, prompts and more!

Continue your journey with these diverse mixed media and art journaling titles from North Light Books:

978-1-60061-456-9

978-1-4403-0317-3

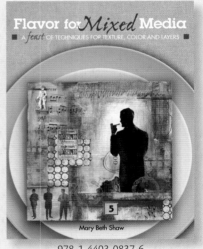

978-1-4403-0837-6

*These and other fine North Light titles are available
at your local craft retailer, bookstore or online supplier.*